f a n t a s y
m a d e
flesh

the essential guide to erotic roleplay

by Deborah Addington

greenery press

Acknowledgments

When I read books, I always imagine a solitary writer, pounding away with words, making beautiful somethings out of lettery nothings as they create, edit and refine – all by themselves.

When I write books, I realize how much love and support it take to help one solitary writer get through the words all the way to something meaningful. These are the people who midwifed this book.

Michael and Alesia Matson; whose dedication, determination, support, and gentle, loving guidance are priceless and treasured more than I have the words to tell. For countless hours of editing and injokes, I thank you. Have a cinnamon roll for me.

I acknowledge and thank Kris Coffman, whose amanuensizing made many a day easier so that I could do my job. She, too, will find the hats that fit her someday.

My beloved Aunt, Mrs. Lois E. Fisher, whose consistent support and love can only be measured in years;

My Melli (Ms. Melisandra Leonardos to you), who better not ever call me that name in public – she knows why I thank her.

Elisabeth Crane is simply amazing. I am lucky to have her in my life. Thanks for the pizza and the unconditional love.

To Mark and Jeannie Bucher, I offer my humble thanks for a place to do this thing, and enough carbohydrate snacks to have done it. Such gracious, generous people do not grow on trees.

I thank and applaud my Darling Beej, Mr. Brian Hall, Super Genius and pirate inspiration extrordinaire.

To Jay Wiseman, I say thank you; I trust he knows exactly what I mean.

Thanks to Rhonda Hallock and Regina Hatch for feeding and bodyguarding efforts on my behalf.

To my Mother, who in all likelihood will never read farther than this page, I offer my thanks, and assurance that yes, this is a real job.

I thank Tim Lauderbaugh, Eva Lyons, Beorn Zepp, Jen White, and everyone else who helped and supported me by knowing when to let me work, and knowing when to make me martinis. I thank my publisher for making this possible, and last but not least, Mr. Tux E. Toes, for making sure I had sufficient feline supervision

Dedication

Music is your won experience, your thoughts, your wisdom. If you don't live it, it won't come out your horn. –
Charlie Parker

This book is dedicated to Michael and Alesia Matson: teachers, playmates, friends mentors and Family. Without them and their clear choices, neither this book nor my Self would have happened;

and to Zane Brett Addington, for never being embarrassed and for being the greatest love of my life. May you find the roles that reflect Who You Are, my bright and brilliant sun!

Contents

Author's Note

All are lunatics, but he who can analyze his delusion is called a philosopher. – Ambrose Bierce

This is a book about imagination, creativity, fantasy, lust and play. This is a book about the things that please my soul. This is also a book taking stock of what's inside. This book is also about fear, doubt and shame: the things that tend to leap out at us when we make attempts to imagine, fantasize and create. Especially if we're doing so with an eye to mixing play and pleasure for no other reason than because we want to, *because we can*. This book is about pleasure, discovery and passion.

This is a book about following your bliss. Nothing happens by accident; if you're reading this, you're ready. I hope that doesn't frighten you too much; it scared the hell out of me. But it seems I've gone and done it anyway.

This is a book about stepping outside the uncomfortably small slots and notches that conformity permits. Please don't conform to my particular brand of nonconformity. Do it your way.

Some of what I have to say will be contentious; it may make you uncomfortable. I think that's a good thing. Challenges show us our discomfort; discomfort tells us what we fear and fears tell us where our passions lie. Challenges help us evolve; our capacity for fun and pleasure evolves right along with us. The more we evolve, the more fun and pleasure we get to have. It is my wish, my fervent hope, even my prayer that you will find herein the impetus and tools for the discovery of your Truth, your roles, and all the passion and glory that comes with their expression.

Welcome

Sell your cleverness and buy bewilderment. – Jalal ud-Din Rumi

I invite you to step into the remarkable world of your mind, your imagination and your fantasy. You know the place – it's the section of your internal landscape that the world has been trying to manicure with the pruning shears of "should" and the lawnmower of "ought" since you were born. Perhaps you're well versed in its topography because you spend a lot of time there, wandering the rooms and gardens. Perhaps you're largely a stranger to your innerscape, because there's always so much to do on the outside of your skin, and you simply haven't the time to go wandering about in a place that isn't "real."

Permit me to attempt to change your mind, should you be one of the latter; permit me to congratulate and encourage you if you're one of the former.

That place we go to woolgather, to daydream, is just as real as any other, and you are the sole owner and proprietor. You can rent a dwelling or lease a car, but that innerscape in all its abundant luxury (covered, as it may be, in thick dust and cobwebs, or wild and fascinating like an unexplored continent) is entirely yours to do with as you will. Some housekeeping may be in order in the chateau of your mind, the palace of your imagination. A task is never as daunting as the anticipation of it.

Reading this book may cause distress by requiring you to probe deeply into the conscious and not-so-conscious areas of

sex and creativity, causing you to deal with the consequences of probing your own mind. To do so is not encouraged in this world; I encourage you to become a rebel (as if you weren't one already, simply by choosing to take control over your own sexuality and by reading this book).

Some of your fantasies may disturb or even alarm you; I ask you to judge neither them nor yourself for having them. They are neither good nor bad; they simply are. And you have the ultimate power of control in deciding which of your fantasies you make real, and which ones are best left swirling in your imagination.

Reading this book and accepting the challenges it contains may lead you to new heights and depths of pleasure, the likes of which you've only dreamed about. You may be on the verge of taking on the responsibility for your pleasures and the realization of them in a whole new way.

Fantasies happen first in our minds. Sometimes they creep unbidden into our thoughts during the commute, while doing the dishes, or in the middle of an act of intimacy. Erotic roleplay takes a fantasy, our Selves speaking in the fluid language of the imagination, and translates it into a tangible reality. For those of you who have tried to make this translation, you'll recognize it to be easier said than done. I encourage you, and hope to enable you, to learn the fluency of your own inner language, and to learn how to translate those thoughts and images into a tangible, sensuous, skin-on reality.

Are there any fantasies that should be left in the realm of thought, never to see the light of reality? I say no – *with a condition*. There are no "bad" fantasies; just those we judge to be somehow wrong. Whatever happens in your mind is appropriate to you, and there's not one thing wrong with it. Socially, right and wrong become an issue when we're deciding which fantasies to enact. Any fantasy you choose to enact must be accompanied by the willingness to take full responsibility for the outcome and its consequences. It is entirely possible to enact a fantasy, to evoke the power and rush of taboo images and acts, without engendering the consequences of making the act

a full reality. That's part of the reason we do this: to liberate a captive image without permitting it to become a governing thought. Should you choose to break a law in order to enact a fantasy, be advised: you will be punished by the system accordingly. What's worse, when you choose an action that violates your own inner laws – the truths of you that make you unique – you engender consequences that are extremely unpleasant.

Violating the law is bad enough; externally imposed social consequences occur; most of them suck. Violating your integrity is worse; that makes you a conflicted and embattled person. I do not advocate the breaking of any laws in order to live out a fantasy, internal or external. I do, however, strongly advocate finding out where your own inner laws are, and challenging them to the fullest so that you can have as much fun as you can stand.

When we pay good money to go to a movie or a show, we expect to be entertained: the crew and performers have put forethought and effort into what they intend to entertain us with. Our interpersonal interactions should be treated with no less care and consideration In the realm of erotic roleplay (ER for short), we occasionally need a little help figuring out what we want, giving ourselves permission to have those desires. Generally, we need to learn – from something or someone – the communication skills with which to share that information with others in order to bring our fantasies into flesh. That kind of direct, unflinching communication isn't fostered in our culture. It's too honest and straightforward. Lots of people can't even have a dialogue with themselves on that level, let alone with someone else. That's not a criticism, it's a statement of fact. We're so outward-driven in this culture that we forget to be selfish enough (in the good way) to learn our boundaries and how to convey them to others. Communication is critical to ER: if you can't ask for what you want, the odds of getting it are greatly reduced.

It isn't always easy to craft a rewarding scene. Negotiating gives you the lines within which you are to color. That's

clear. But what to color with? Marking pen? Crayon? And what colors to use? The director or person in charge of setting the scene is a midwife; all the participants are the progenitors, but the scene is an entity unto itself. When we roleplay, we bring that entity into being; we incarnate the fantasy. What's offered in these pages are suggestions and the benefit of experience in crafting scenes that will keep everyone engaged and striving to realize their highest pleasure potential.

Life's too short to limit one's sexual experience to missionary sex with the lights off (unless, of course, that's your particular kink), especially when there's a magnificent world of experience waiting to be discovered. Roles notwithstanding, people who choose to actualize their fantasies are perceived as being a bit avant-garde, more than a little risqué. You needn't identify as kinky to do erotic roleplay; you needn't identify as anything but you.

No one can tell you if you're kinky or not; that's a distinction you claim or reject all on your own. I suspect most of us humans are at least a little bit kinky, a little bit interested in doing things we're not "supposed" to, in ways we're not "supposed" to do them. You need not identify as kinky, with all the stigmas that still linger with that distinction, in order to expand your sexual repertoire; the acquisition of fetish clothing or expensive props is not required (unless, of course, they'd fit in the scenes you wish to create). Kinky or not, if you've the courage and integrity to be reading this, bravo/brava! It's your head, they're your fantasies, and you can do whatever you like with both.

For anyone wishing to expand their repertoire – members of the BDSM[1] community and "vanilla" folk alike – the incarnation of fantasy can be an intimidating challenge. For all of us, regardless of orientation, in the name of pleasure, growth, and satisfying personal encounters, I offer you this challenge: discover how much pleasure your mind and body can stand.

1 Bondage/discipline/dominance/submission/sadism/masochism: an umbrella term for alternative intimacy practices.

Section One: The Bones of Fantasy

fantasy
made
12 flesh

1. Some Vocabulary and Definitions

Learning is movement from moment to moment. – J. Krishnamurti

This is supposed to be the "essential" guide to "erotic roleplay." That being so, we'd better discuss some basic terms, like "essential" and "erotic" and "roleplay," before we go any further.

Essential means basic. The bare bones, the rough outline, only that which is necessary to begin. This guide offers the primary things one needs to know in order to put a scene together, both inside your skin and out.

Ah, "scene" – there's another term just begging for a definition. Mine: a set time and place for an interaction focused around specific elements of energy exchange, with a pleasurable goal in mind.

"Pleasure" is a term I refuse to define, because I can only do so for myself. You know what pleasure means to you; we'll leave well enough alone on that score. That leads

us straight into "erotic" and "roleplay," but one thing at a time. Let's tackle "erotic" first. Janet Hardy[2] has this to say:

> I've had to resort to the word "erotic" in order to explain – as I often do, in my role as educator – how someone could enjoy, say, doing his mistress's dishes, without ever being overtly sexually turned on by it. A heightened consciousness, a sense of "rightness," a connection with a self that isn't accessible by other means: to me, that's eroticism.

The American Heritage Dictionary says erotic is "of, concerning, or tending to arouse sexual desire." The root of the word erotic is the Greek *Eros:* the god of love, who also happened to be Aphrodite's son and is the equivalent to the Roman Cupid. As far as I know, Cupid's arrows (arrows, eros – interesting homonym pair!) weren't about slinging physical lust from his bow, but were far more amatory. We humans being who we are, it's a natural drive for us to want to share ourselves physically with those we love. So contemporary usage of the word "erotic" comes from a leap in logic, connecting love to the human desire to connect physically with the beloved. From there, *eros* becomes "sexual love." Something erotic may give me a hard-on (yes, I'm a genetic female, but I prefer not to genderize my euphemisms), but the hard-on isn't my focus; it's a byproduct of erotic energies flowing through me.

To sum up: erotic is that which establishes a connection to Self through sources of love, with the option for that love to express itself in physical acts or exchanges.

That leaves us with roleplay.

A role is a set of behaviors one emulates in order to convey an impression of character. In a theatrical sense, one learns lines, dons costumes and behaves in such a way that the audience will get the picture. In our roleplay, it's pretty much the

2 aka Catherine A. Liszt and Lady Green, author or co-author of *The Compleat Spanker, The New Bottoming Book, The New Topping Book,* and *The Ethical Slut* (required reading for anyone who wants to share intimacy with me)

same. We choose a persona, identify key elements to that persona, adapt them to our surroundings, and act the role out.

Roleplay in this context is not necessarily the putting on of a role foreign to the self. If one identifies as a "slave," for example, one may choose to wear a collar. It may not feel like a role; it may feel totally organic and natural. Still, it's a form of roleplay, in that it affords the deliberate expression of a highly specified role: slave. We aren't permitted to identify as "masters" and "slaves" in everyday life, even if those roles are completely integral to who we are, even if they're deeply embedded in the psyche and ingrained in the personality. When we give ourselves the opportunity to exercise those tendencies privately, we are taking on a role. I can hear the objections from here: "That's not a role for me! It's a part of who I am!" Indeed! But even if something is a part of who you are, no one facet of you is all of who you are.

When you choose to act out a facet of your Self specifically, with focus and deliberation, you are acting out a role. I would also point out that it is so with every other role we take on: parent (we may be parents, but the role of parent is something we take on deliberately), child, lover, friend, companion, fool, professor, poet, lunatic, fiend, philanthropist – all of it is role. Be it parent or Mistress, every role we take on is an expression of at least one facet of Self.[3] The key difference is in comfort levels with the roles we're encouraged to take on, the ones that are widely accepted, versus the ones that aren't quite as socially condoned.

Please do not make the mistake of treating "role" and "artificial" as though they were synonymous; just because one

When we are really honest with ourselves we must admit our lives are all that really belong to us. So it is how we use our lives that determines the kind of men we are. – Cesar Chavez

3 You may have noticed the capitalized use of "Self." I make the distinction between that and lower-case self to indicate the difference between the everyday self and the higher Self. I'll do the same thing with Other, the difference being others that we run across all the time, and the Other, the highest octavie of experiencing ourselves in the mirror of another being.

takes on a role does not mean that one is behaving in an artificial fashion. When we assume a role in erotic roleplay, we are concentrating on an aspect of Self that has no other appropriate, pure outlet. In a scene we are just as much ourselves as we are at any other time. That one role, that one facet of Self, leaps to fore, and there is no room for anything other than what is completely true for the Self in that moment.

That's why we do this "weird" stuff, you know. For the passion, intensity, and singularity of focus it affords us. That, and it's fun, and feels really, really good.

Role is the easy part of roleplay; it's the "play" business that throws us for a loop. Children are permitted to play – until they reach a certain age. They are then encouraged to put away childish things – play being at the top of that list. As adults, we're not encouraged to play just for the sake of playing. It becomes highly competitive, whether we're trying to beat an opponent (tennis, chess) or group of opponents (football, baseball) or if we're trying to conquer an aspect of nature (mountain climbing, golf). The key difference between child's play and adult's play is goal orientation. Children play for the sheer joy of playing; it's a pure expression of natural tendencies. As adults, it isn't considered play unless there's someone or something to be (ahem) beaten. Roleplay permits us to play as a pure, joyful, focused expression of a part of who we are – and if we're lucky, a little sexual gratification comes with the package.

When we put it all together, what we have looks like this:

Erotic roleplay is the prerogative of "let's pretend" intertwined with the adult prerogative of pleasure that permits access to gratification inaccessible by any other means.

If it's all so straightforward, why read – or write – a book about it? Because as a groundbreaking author once wrote:

The source of sexual power is curiosity, passion. Sex does not thrive on monotony. Without feeling, inventions, moods, [there are] no surprises in bed. Sex must

be mixed with tears, laughter, words, promises, scenes, jealousy, envy, all the spices of fear, foreign travel, new faces, novels, stories, dreams, fantasies, music, dancing, opium, wine. Only the beat of sex and heart together can create ecstasy. – *Anaïs Nin*, Delta of Venus

Together, in these pages, we'll explore sex, heart and fantasy and discover the permissions to blissfully entwine all of it.

2. Fundamentals of Erotic Roleplay

The artist, if he is not to forget how to listen, must retain the vision which includes angels and dragons and unicorns, and all the lovely creatures our world would put in a box marked Children Only. – *Madeleine L'Engle,* Walking on Water

The general assumption seems to be that only kinky people – those folks somehow engaged in the dark and taboo world of BDSM – do erotic roleplay. I happen to know that there are, in fact, a goodly number of those folks who do erotic roleplay – and just as goodly a number who don't. I also happen to know of a number of people not associated with kink – the kink vernacular for people who aren't kinky is *vanilla*, which happens to be my favorite ice cream – who happily, frequently and expertly engage in erotic roleplay. Erotic roleplay is not the exclusive dominion of the leatherclad. Erotic roleplay is the dominion of anyone who has ever used a silk scarf to tie a lover to the bedpost, anyone who has ever indulged in something naughty, anyone who has ever "done it" in the kitchen with all the lights on. Erotic roleplay is the dominion of anyone who has so much as thought about doing something outside the pro- scribed sexual norm. I know monogamous roleplayers, and roleplayers who are polyamorous (who get their intimacy fix from more than one significant source). I know young people (no one under the age of 18, of course) and older people (a

friend in her 70s was thrilled to show me her new collar and matching cuffs) who roleplay erotically.

So far as I can tell, erotic roleplay does not discriminate on the basis of age, gender, sexual orientation, race, or even religion. A friend who recently attended a Christian marriage retreat informed me that it was suggested, in order to put some spark back in the bedroom, that they put on nice clothes, meet somewhere amenable, and pretend they didn't know each other. I'd call that a pick-up scene, and if that isn't roleplaying, I don't know what is.

On the surface, ER takes little more than a willingness to explore a fantasy, and a bit of imagination to carry the fantasy through to a reality. That's on the surface. Underneath, there's more going on than meets the eye. To be willing to explore a fantasy, one must admit that a fantasy is present. To actually go forward with the exploration of a fantasy that involves another person, the concept must be communicated. Our culture isn't really keen on the type of communication that's involved, especially with the vulnerability that can come with the expression of a fantasy. When it comes to imagination, many of us are totally hapless. We are so discouraged to imagine anything but ways to earn more money or to live the American Dream that we have forgotten how to imagine. Not that a healthy pocketbook is a bad thing, but any activity taken to extremes has the potential to become volatile, including the pursuit of fantasy.

So maybe this roleplaying idea isn't so simple after all.

> *To know what you prefer instead of humbly saying Amen to what the world tells you you ought to prefer, is to have kept your mind and soul alive.* – Robert Louis Stevenson

3. The Three Pillars of Erotic Roleplay

The triangle is the most stable structure in nature; it has in inherent balance. In Aikido, a martial art, one is taught to use one's legs and a third, invisible "leg" – an extension of the center of gravity – to create a stance resistant to toppling. Triads exist in almost every known Mystery, and the interactions we create with one another in an erotic context definitely qualify as a Mystery. From Catholicism to Druidic practice to Wicca to Zen, things get grouped in threes: Father, Son, Holy Ghost; Maiden, Mother, Crone; Life, Death, Rebirth; the Three Redes; Thought, Word and Deed; Body, Mind and Spirit. Psychological and emotional cycles often manifest in three stages: beginning, middle and end; small, medium and large; past, present and future.

The unconscious wants truth. It ceases to speak to those who want something more than truth. – Adrienne Rich

Erotic roleplay is possessed of a magic of its own: the magic of transformation. For however brief a spell, we can go wherever, be and do whatever we wish. We transform ourselves, our spaces, and our actions into something new, different and exciting. We can become someone else, be somewhere else, and interact in ways the mundane world does not permit. We make magic happen. This process of transformation and creation has, at its fundament, a triad of its own: the pillars of Desire, Passion and Fulfillment.

❧ Desire

As a verb, *desire* means to wish or long for, to want, or to express a wish for. As a noun, it means a wish or longing, a request or petition, the object of longing. It also denotes sexual appetite, passion. Abbreviated: desire means you gotta want it, baby. Two things are implicit in that: the act of wanting and a thing to be wanted.

Desire is stronger than its cousin, want. Wanting really isn't strong enough to make us do something; want is the diluted version of desire. An armchair quarterback might want the game to be won, but the real player out there on the field *desires* the victory. There's a drive, a force in desire that wanting does not possess. Want won't get your ass up off the couch; desire will not permit one to remain *upon* the couch. Desire is the first element in the construction of a scene; imagination, necessary to the creation of something *to* want, lives in the realm of desire. A desire to perform some act, generally with a person or persons also desired, is key. Again: you gotta want it, baby.

Desire is necessary to beginning the process of constructing a scene. A person or an activity must be desired; a scene begins at this point.

An activity may be the starting point, with the participants to be chosen later (I'd really like to do a pirate scene[3]; who can I ask to do that with me?).

A certain individual or group with whom one desires to engage may be the starting point (I'd really like to do a scene with Jane and two of her housemates; I wonder what they're into?).

The circumstance will dictate the person(s) required to fulfill the desire, or the person(s) involved will sculpt the activity. Either way, a stage is set; the specifics will come from the desire. So begins the act of creation and transformation.

3 For the sake of consistency, I've used a pirate scene as my sample erotic roleplay throughout this book. That's not because I think of pirate scenes as the perfect roleplay – although I certainly am not in the habit of turning them down – but simply because pirate scenes appeal to a lot of people, including me, and incorporate many different aspects of ER.

ᏗᏂ Passion

Boundlessly enthusiastic, *passion* is a pillar – because without its force, the creative energy it contains, all you have is a really hot idea. Desire requires passion to bring it from the realm of thought into the realm of the tangible. Conversely, without desire, passion is a huge force lacking direction and focus. Passion has not so much to do with any one particular emotion, but rather the quality of any given emotion. It's powerful, a step up in intensity. Passion provides the heat that allows the seed of desire to grow to fulfillment.

Love, joy, hatred and anger are commonly seen as passionate emotions, but there's no one particular emotion synonymous with passion. Passion also connotes ardent love and strong sexual desire or lust, which have definite manifestations in the physical world, especially within our context of ER. Passion almost always has an object of desire. Passion is what gets desire up off the couch, to move, to breathe, to become. Without passion, desire remains in the realm of thought; with passion, desire begins to solidify, to acquire depth. In its archaic form, from Latin through French, passion shares a root with suffering (a delightful irony, given our present context). And *com*passion is the ability to suffer with – not for – another being: a skill all scene crafters and erotic roleplayers should have. After all, how can we truly savor what we do with another unless we understand it and can share? And think how much more fulfilling the experience is when it *is* shared!

fantasy made flesh
22

We learn to do something by doing it. There is no other way. – John Holt

ᏗᏂ Fulfillment

The third pillar in constructing a scene is the *fulfillment* of the desire that has been fueled by passion. Fulfillment means to bring into actuality, to effect the transition from idea to action, to carry out (an order, for example). It also means to

measure up to, to satisfy. It closes a circuit, brings to an end, completes. It carries a feeling of satisfaction at having achieved your desires. By closing the cycle of energy exchange that is initiated by desire and passion, the circuit of creative power is complete and the dimension of breadth is added, leaving in its wake a fully-realized three-dimensional experience. Without fulfillment hot on the heels of desire and passion, one is left feeling bereft, dissatisfied, somehow cheated. A lot of creative energy is brought into being and then consumed by the potent combination of desire and passion; something must then be done with all that electricity that's been generated lest it turn rogue, with no focus or intent. Fulfillment permits those potent energies their appropriate outlet. It focuses the power in a scene, funneling it through direct experience. It is closure and completion, the ground for the electricity people create for – and with – one another. As a bonus feature, fulfillment also creates the grounds for the next desire, cultivating a thoroughly pleasant upward spiral.

The life which is not examined is not worth living. – Plato

With these three pillars in place, we have a foundation, the bones upon which a scene will be built. What shape and form that scene will take is governed by imagination, an inborn skill that we're gradually talked out of as we "grow up." We're encouraged to take on some roles, certainly, but showing up at work in a pirate hat and cutlass is frowned upon. You can sit in your cubicle and *think* about wearing a pirate hat and cutlass, but doing so is another matter entirely – a matter many have a tough time actualizing. Imagination may dwell in the realm of desire, but it's just another law-abiding citizen until it is given free rein in the mind. Many of us have lost access to our imaginations: using imagination, let alone acquiring the permission to make the creations of imagination real, is a sticky wicket in our culture.

4. Liberating Imagination

I have never been contained, except I made the prison. – Mary Evans, actress, 1888-1976

Imagination is all about control. Obtaining enough control over the mind to get it to relax is even more rigorous than paying attention to something incredibly dry and boring. We usually have enough control over our minds to stop them from woolgathering; we're taught that. But as adults, where do we find the type of control that allows us to relax those other rigid controls?

❧ Practice

When I first decided as an adult that my imagination was a place I wanted to explore, I was a bit daunted by how much effort and actual work it seemed it would take to pick the lock on my mind and swing wide the rusted, heavy steel door behind which I'd been taught to imprison my fantasies. Please understand that I am, at heart, a hedonist who specializes in maximizing the results of my efforts. I'm not lazy *per se;* I prefer to think of myself as efficient. I don't go in for self-help materials, and I'm fairly stubborn about changing my habits. On the other hand, I'm flexible and willing to learn new things when I choose, and opening my imagination was a deliberate and conscious choice. You hover on the verge of that choice right now, if you haven't made it outright.

ᖇ Play

Adults in our society are not encouraged to play, and that's more unfortunate than I have the words to express. Play is the point of this particular game, and culturally, we're not very good at it.

The Protestant work ethic states that those who do not work don't eat. What about those who don't play? What happens to them? They become codified, rigid, bored and, what's worse, boring. I've done my stint as a pretty boring individual. I had crises, drama and pain galore. I used to think that I couldn't play because of those things; I now know that I had those things because I couldn't play. "Lighten up" is the vernacular: how apt. We're all so heavy, we drudges, those of us who plod through our own lives and the workaday world. By the end of a good day's trudge, we're so bloody tired that there's no energy left for play, for creativity to rear its lovely head. Without the play, we don't just do the work of a drudge; we become the drudge. Our will to live is not sapped from us; we surrender our will to live by not permitting ourselves to do exactly that: *live*. We work, we struggle, we plan, we strive, we pray, we hope, we fear. All those things are included in the package deal of life, but not one of those things can replace the act of living itself.

It is in the knowledge of the genuine conditions of our lives that we must draw our strength to live and our reasons for living. – Simone de Beauvoir

fantasy made flesh **25**

It wasn't until I learned the balance that I was able to learn how to play, how to work, and how not to take either one more seriously than was absolutely necessary. I had to get over myself. I had to find a way to silence my saboteur, my critic, and end its censorious ways. Determination and persistence are helpful in this endeavor but, above all, it takes a commitment to yourself. Remember the three pillars? This is your first opportunity to experience desire: your own desire to become more of who you already are. You'll easily be able to manufacture several dozen (at least!) reasons not to do what I'm about to suggest; you may go so far as to give yourself permission to do

it halfheartedly before you decide it's all just too silly, and quit. I can tell you a secret about that: if the practices you're about to read are too silly for you to do, then erotic roleplay may be too silly for you too. That's just fine; that hardly makes you a bad person or anything like one. It's worth noting, though, that if you can't play with your own brain in private, there's little chance you'll be able to unlock it for yourself, let alone share a frolic or play in the minds of others. I strongly recommend you begin this undertaking privately, not sharing your ideas outside your notebook (that was a hint – you'll be needing pen and paper). You may eventually wish to share your thoughts with another, but while you're working on accessing what may be a very fragile matrix, it's best to keep your own counsel. I also strongly suggest that you keep your notebook and pen handy, writing things down as they come to you, without censoring or editing. Nothing kills newborn flights of fantasy faster than criticism, especially self-criticism. There is no right or wrong way of doing this. There is right for you and wrong for you. What I offer you is what has worked for me, and others I know. A great deal of trial and error has gone into this; feel free to add more of both. Failure is judgment imposed on experience, so relax, let go, and just have an experience with your Self.

Man can learn nothing except by going from the known to the unknown. – Claude Bernard

ꙮ Fear

To live a creative life, we must lose our fear of being wrong. – Joseph Chilton Pearce

The very word "fear" is frightening. We're trained to be afraid, instead of being aware of fear. Powerful and intense, our fear serves a purpose: when the red flag of fear pops up, it's sending you a message that you're coming awfully close to something that may change you. Fear is everything you're not, or are afraid you aren't. As we tend not to like change, it makes sense

that fear would serve as a warning of change. Fear, when used as a tool, can show us exactly the direction we'd most benefit from. But we're not taught to use our fear as a tool. We use it as a weapon, on ourselves and on others. We fear being afraid, because that must mean we are weak or inferior. We can, in our less shining moments, use others' fear of us in an attempt to manipulate them into doing what we want.

"I'm afraid" isn't the positive, exciting expression of forth-coming experience that it's meant to be; it doesn't usually mean, "Ah ha! I'm approaching something that challenges me and what I believe is so; I will face this challenge and allow my fear to guide but not govern me." In our culture, "I'm afraid" means that one is somehow broken, inadequate, worthless, weak. We work very hard at finding ways to be not afraid, thereby completely invalidating fear's use as a tool. We not only ignore the message, we ignore the messenger! We deflect, obfuscate, deny and re-route. I propose a novel concept: fear is not a weakness, but one of humanity's greatest strengths.

Basic fears, like being afraid of putting one's hand in a fire, are very helpful. Those fears prevent damage being done to the body. Like pain, fear happens before damage is done; it's a warning system, and a very good one. One can heed such a warning without being governed by it. When it comes to erotic roleplay, the first thing one dashes headlong into is fear: fear of being wrong, fear of appearing silly, stupid, foolish, inadequate, unskilled, a failure or worse. Fear is the biggest obstacle between you and the erotic roles that appeal to you. Fortunately, the impact of your fears is within your control.

Fear Challenge #1

If a man wants to be sure of his road, he must close his eyes and walk in the dark. – St. John of the Cross

We're going to go for a little stroll in the dark. It's time for the pen and paper I mentioned earlier. Before you go on, make sure you have some time and space for this; it's best done when and where you can achieve and maintain some focus. If

you're in a hurry, or reading this while killing time waiting for an appointment, stop here and come back when you have a moment. Don't do what I've done a million times: don't shoot yourself in the foot by reading ahead when it says not to and then overthinking things.

Without really thinking too much, and with as little criticism as you can manage, make a list of every single reason why you could never do erotic roleplay. Include everything you can think of that stops you from doing ER. Leave room to add more reasons as they emerge; add to your list as necessary (even if a new reason pops up a week or a month from now). There are no right or wrong responses to this challenge. Just let them come; no reason or thought is too silly to write down. They are all yours, and they are all real, true and valid. There is no time limit other than to ensure you have all the time you need to make the list. I do ask, though, that you read no further until you've met this challenge.

Now, put this book down and just write for as long as it takes. I'll be right here when you've finished.

Fear Challenge #2

And the day came when the risk it took to remain tight inside the bud was more painful than the risk it took to blossom. – Anaïs Nin

After having written a litany like that, you may feel angry, tired, drained or sad. You may feel like you need a nap, a bowl of chicken noodle soup, or a punching bag to pummel. Grant yourself the item(s) of comfort you may be asking of yourself; you've earned it. It's not easy to evoke fears, to bring them into the light of day where they can be accurately examined and evaluated.

After you snuggle your teddy bear, eat your soup, or beat the stuffing out of a pillow, you're ready to move on to the next step. That may be half an hour from now, it could be tomorrow or next week. There's no rush, but try not to put it off any longer than you really need to, and keep the list handy.

We're going back in. This time, however, we're going back in with more of an intellectual eye to things and less of an emotive one. Read your list once through in your head. When you've done that, read it aloud. Yes, *out loud*. Speak every thing you wrote. Give it voice. Pause in between each item on your list, and deliberately notice how speaking that thing made you feel. Queasy? Anxious? Enraged? Depressed? You needn't do anything about those feelings just now; simply notice them. They are just feelings – your own – and cannot harm you. Go ahead and feel them. You have my permission (just until you find your own, of course) to feel angry, sad, terrified, distraught and anything else that comes up. These feelings may not be pleasant. In fact, they are likely to be quite unpleasant. You are not broken because you feel unpleasant things; you do not need to be fixed. Try not to mistake unpleasant for bad or wrong, and do no more than take note of your emotive responses to your list. Feel. I ask no more of you than that: just feel and notice those feelings. No action based on those feelings need be taken right now.

It may not feel like it quite yet, but you have just identified and isolated, with concrete, tangible proof, a very useful diagnostic. You have before you a lexicon of your Saboteur's vocabulary. This tool is invaluable. Your Saboteur is the part of you that works diligently to keep you from looking at things within and without that might cause change. It has, in our culture, far outgrown its original purpose: a warning system to get our attention and help us pay attention to important choices and opportunities. It has overgrown itself and routinely oversteps its boundaries by intimidating us into doing what it thinks we should. It stops us from playing.

You now have a means by which to address your Saboteur. You have examples of exactly what it sounds like, and ways in which it tries to make you so fearful of something that you'll never even attempt it. It's a part of you and it isn't a bad thing, it's not the enemy. Like an errant child, it has gotten out of hand in its behaviors, and the first step in re-training it to assume its proper role is to identify its voice, its vocabulary.

Once you've come to the end of your list (which may feel remarkably similar to the end of your rope), it's time to go back to the beginning of it. This time, as you go through it one negative statement at a time, you're going to add to it. Your additions are to have a specific format: for each negative, unpleasant reason you have with for not being able to do erotic roleplay, you're going to craft a positive, true statement to counter it. By true, I mean something that is either true for you right this minute, or something you would dearly like to become true for you in the very near future. If a statement ran something like, "I can't do erotic roleplay because I don't want to look silly," the counter to that might be, "I can do anything I want because I embrace my silliness. It's okay with me to be silly." "I can't roleplay because I have no imagination" could be countered with "I am taking steps right this minute to reclaim my imagination; I offer myself the gift of my own patience." "I look dumb in a pirate hat" can be met with, "Well, maybe, but there are many other hats out there, and the only way to find out if one fits me or not is to try it on."

Do not weep; do not wax indigant. Understand. – Baruch Spinoza

However you go about it, be certain to counter each and every single negative statement with a positive one. Leave no stragglers; round them all up, and find them a mate. You may find yourself far more challenged to create and state something positive about yourself than you were in coming up with the fears. Don't be alarmed: that's normal. Or common, rather – our normal state is generally a lot more positive than that. But we're taught to pay more attention to the negative than the positive, and the Saboteur loves that.

Susan Jeffers says, "We have been taught to believe that negative equals unrealistic and positive equals realistic." Another common misapprehension regarding positive and negative is that positive is synonymous with pleasant, and negative with unpleasant. That is what we're taught. I offer a shift in that perception: negative is what drags us away from our Selves;

positive draws us closer to who we are. In that light, even something that is completely miserable, awful and rotten can be a positive experience – as long as it helps us discover more about who we are. Of course, one way we discover who we are is by experiencing who we aren't. Learning about who you aren't is just as valuable (if not more so) as learning who you are – even if it can, at times, be a bit less pleasant.

Viewed from this perspective, subjective evaluations of one's own experience can change dramatically. When we have an experience, we tend to judge it: good, bad, right, wrong. I encourage you to have experiences (maybe even ones that involve pirate hats) and evaluate them not according to how pleasant they are, but to how well they serve you in your quest for Self. You've recently made the acquaintance of a very potent part of your Self; perhaps this challenge reacquainted you with that facet of Self. Now that you've made contact, you have gained a powerful tool in learning how not to beat yourself up with your own Saboteur.

5. Acquiring Permissions

You will do foolish things, but do them with enthusiasm. – Colette

Permissions are the agreements we have within ourselves as to what is and isn't permissible for us to think, say and do. We have lots of everyday permissions: we agree to stop at red lights, we pay sales tax without really thinking about it, we smile when smiled at, we say hello when we meet people, we use a restroom to relieve ourselves. In most daily cases, we do what's considered appropriate, acceptable and "right" in the eyes of our culture. Cultural permissions – what we're trained and taught to believe is acceptable – are a function of the collective consciousness, and that collective is made up of each one of us. For each one of us who examines and chooses our permissions, we influence the thought of the collective. The collective then exerts its influence, and the cycle continues. It's like voting, only more honest and direct.

In ER, we are dealing with a deeper layer of internal, personal permissions, the layer of permissions that define how we choose what's acceptable for us, especially in the erotic arena. Is it okay to masturbate with the bedroom door open? Is it acceptable to dance naked while singing loudly to a favorite tune? These permissions grant us more intimate encounters with ourselves and others; they allow us to do (or forbid us from doing) things like kissing on the first date, having sex with the lights on or with more than one person at a time. There's no overall

right or wrong to them, but these permissions are all about what's right and wrong for the individual. Examining your unconscious permissions gifts you with valuable information and shows you how to craft and activate conscious permissions; conscious permissions make our innerscape bigger.

Donna Reed and June Cleaver did everything by the book; they were the ideals women were to aspire to in an era when acting out one's fantasies was seen as deviant sexual behavior. They're no longer held up as the ideal role models, but I can envision a really hot scene with the two of them doing delicious and naughty things to one another. Who'd have thought that such sterling examples of womanhood in all its big-skirted, pearl-necklaced glory could become such fine fodder for a bit of trouser heat?

The person "controlling" the scene assists the other in getting beyond themselves; the person "submitting" enables the controller to get *into* themselves. It's not a matter of one person doing something *to* another; it's a matter of people doing things with and for each other. We do not pretend when we roleplay; we embrace. In order to do this, we must first have given ourselves permission to do so. Somewhere, on some level, if one uses a flogger on someone, or if one allows one's self to be tied to a whipping post, an internal permission has been given.

I was always the one tying my brother and a friend to a chair, being the evil witch locking them in a dark closet, or having my neighborhood pals carry me around on a lawn chair while I pretended to be Cleopatra. A friend remembers always being the abducted Indian princess, or helpless captive maiden. Neither of us remembers asking anyone for permission to do these things. We just did them, and the kids who wanted to play along did so; the ones who didn't want to play did something else. No hard feelings involved – just a different choice of activities. It wasn't until much later that we remember a sense of guilt and shame attached to doing what came naturally. Because we are taught guilt and shame around the things we

"shouldn't" do (but keep doing anyway because they give us so much pleasure), we actually eroticize guilt and shame. It becomes connected to our pleasure responses so completely that, as adults, we have a difficult time separating the two.

Let's say that from across a crowded room, you see someone who makes you tingle all over. You know you'd like to play with them. You feel an exchange of energy that piques your interest. You approach this frighteningly intriguing human, introduce yourself. You were right; the chemistry is there. You both want to take it further. This person, with no more than their commanding presence, makes you want to surrender your control, to let them take the power you offer them, transmute it, and give it back to you in a sensuous, tactile fashion that takes you to the Forever Place[4]. You feel eager, anxious. Butterflies are having a rock concert in your belly. But you know what you want; you feel it in your gut. Those feelings, that passion and desire, lead you right into an avenue of fulfillment. One moment you're locked in glances of admiration; the next moment, you're tied up, bent over, and zooming towards Heaven. You exchanged permissions as the first step towards exchanging energies. It happened in a cascade of unconscious permissions, without one permission ever being so much as thought out loud.

We exchange permissions in a virtually unconscious way; we don't stop to ask, "Hmm. Is it okay with me to pick up this flogger and beat that guy?" Or, "Is it all right with me that I be all tied up and then get beaten?" It all happens so fast that it seems as though we know what we want and are simply saying "yes" to it. Ideally, in ER, that's what we learn how to do deliberately: notice those moments and choose in them. On closer examination, there's more to it. Inside, we observe, we weigh and consider our options, and

4 Dossie Easton, co-author of *The New Bottoming Book*, defines the Forever Place as the place "where you feel that you want to keep on doing this forever and ever and ever." I define it as the state of mind in which there is only an eternal, exquisite Now. We're both right.

go for the thing that looks like the thing we want. We choose our words, our clothing and our actions according to these embedded guidelines, designed for us and by us to increase the odds of getting whatever it is we want. ER depends on identifying desires, permissions, and avenues of fulfillment. Knowing what goes on in that process, and then choosing to do it consciously, can only lend accuracy and potency to our encounters. The next part of choosing roleplay, after having learned where our fears block us, is to learn when and perhaps even why we say "yes" to the things we do. Why do we have internal permissions for some things, and not others? Why is a nice, friendly little spanking okay, when being tied to a chair and questioned is not? Who is making those choices – you, or your social conditioning?

Your childhood memories are extraordinarily useful; they can grant you access to what your tendencies were – and probably still are. I do not advise you to tie up your neighbors, or hide from them as if they were in hot pursuit; but I do advise you to recall your childhood play and remember its flavor, its tenor, its mettle. Those memories hold the key to your unconscious permissions, and those lead you to giving yourself conscious permissions: a requirement for erotic roleplay.

Permission Challenge #1

The way in is the way out. – Alesia Matson

This is your first challenge in permissions: remember what your permissions were when you were young. Remember what you loved doing, and didn't ask anyone if you could do. Recall the things you did simply because you could and they felt good. Write them down. You may have outgrown them, but write them down anyway. The challenge is to get at what you had permissions for then, not to see if the stuff you did as a child is something you'd be interested in now (though you may find yourself surprised at the crossover). Don't sit in judgment of what you did when you were younger: comments like "Oh, but

that was just because I was young and foolish; I'm certainly not like that now!" are not permitted. Just as you did with writing down why you couldn't roleplay, don't overthink it. No one will see this but you, and you have my permission to abstain from judging your early experiences. Nothing is too weird, strange or naughty. Did you:

Torment the family cat?

Roll in mud puddles?

Shine your shoes religiously, without being asked to?

Boss other kids around?

Find other kids to boss you around?

Masturbate several times a day, or in strange places?

Sneak into a parent's porn stash?

"Borrow" clothing from someone of a different gender?

Eat out of the dog's bowl?

Sniff worn shoes?

Take a look at your list. Is there anything on it that still appeals to you today? Is there anything that squicks you? What might you still do, and what might you not? There should be at least one or two things on that list that still give you a tingle of thrill. Choose one of those things, and get ready for the next challenge.

Permissions Challenge #2

Trust in yourself. Your perceptions are often far more accurate than you are willing to believe. – Claudia Black

Let's say that one of the things that still tickles you is the idea of sneaking into someone else's underwear drawer, absconding with a pair of forbidden undies, and prancing about in them for your own secret delight. Give that happy image some of your attention. You may not have a resident parent or sibling from whom to borrow underthings, but you may have a roommate, spouse, or loving and gentle friend who won't call the law on you for making off with some lingerie or jockey shorts. Imagine your younger self doing that special thing.

Now, shift and reshape that image to include your present self. How would you go about it? How does it make you tingle? Is the thrill in the sneakiness? Or is the thrill in the donning of the forbidden garment? Both, perhaps? Find the thrill, and give yourself conscious permission to do it again. Now. As an adult. Make an appointment with yourself to follow through on giving yourself one of your childhood permissions. Do it right now, if you can. Don't put it off too long, or you run the risk of your Saboteur talking you out of it entirely.

Permissions Challenge #3

Taking a new step, uttering a new word is what people fear most. – Fyodor Dostoyevski

Congratulations! If you've made it this far, you have: made another list, identified some permissions and experienced an older permission consciously, in a new way. The next challenge should be easy for you now.

Once you realize that the universe is an infinite something expanding towards an infinite nothing, wearing plaids with stripes is easy. – Albert Einstein

Now that you know what a permission feels like to you, and you have a grasp of how your Saboteur will try to talk you out of it, you're ready for the next step. It's time to create a new permission, and act on it. Silliness may seem to be a factor here, but I assure you that nothing is too silly to permit yourself. If you can't take silliness seriously, it will prove difficult to take *anything* seriously. I suggest you begin with something to do on your own; get some practice in, and then include others. Self-consciousness is easier to handle when there's no one else around. Start with something easy, to get yourself in the habit of permitting. Begin with silly; we can work up to the hardcore, very serious ridiculousness later.

If you're normally caustic and curmudgeonly, give yourself permission to be kind – without any expectation connected to it. If you're normally Suzy or Sammy Sunshine, give yourself permission to be bold and forthright – maybe even cruel in the

right context – without guilt. I am not encouraging you do be a raging jerk. No one likes a raging jerk (outside of the appropriate context, naturally – there are times and situations where being a raging jerk is not only called for but desirable). I am encouraging you to step into shoes you may not have worn before, and walk about in them for a moment or two, just to see how they feel, to see if they fit. That *is* the only way to find out, after all.

Your permission does not need to be connected to anything specifically erotic or to roleplay. We must walk before we can run. Something erotic may be just the thing, or something like permission to stop and talk to that fascinating yet frightening homeless person for a moment might be the order of the day. Give yourself permission to take that hot bath with essential oils and candlelight, then have a mindblowing orgasm while you're in it. The idea is to translate permissions for something you've done (like taking an erotic bath) into permission to do something you've never done (like roleplaying a mermaid being tended to). Make a list of things that interest you, but seem just too darned kooky for you to ever consider doing. Don't censor the list; just write it. If you absolutely can't think of anything silly enough, here are some suggestions to get you started:

> Spend at least one hour a day naked (don't cook bacon)
> Paint your toenails – especially if you're a guy
> Eat with your fingers
> Feed someone else an entire meal, preferably without utensils
> Brush your teeth with your non-dominant hand
> Brush someone else's teeth
> Pull out all the pots and pans and make some music
> Talk in baby talk
> Speak with a lisp
> Hump something because it feels good
> Crawl around your house for a different perspective
> Play dress-up
> Sing Sesame Street songs in the grocery store

Finger paint

Skip, gallop or bounce instead of walking

Don't wear underwear for a day

Sing Christmas carols in July

Buy yourself a flower

Create an imaginary friend

Hop through your house

Walk in the rain

Learn to ride a unicycle

Wear socks that don't match

Make up a new word and use it five times in a day; if asked
the meaning, give a convincing definition

Wear your pajamas backwards

Pet a goat

Eat a sundae for breakfast

Mix plaids with stripes

Throw a fingerfood party

Chew bubble gum and pop it

Write down five reasons to be silly

Walk barefoot on wet grass

Choose a letter of the alphabet and only eat food that starts
with that letter all day

Imitate an animal

It doesn't matter so much what you do as long as it meets two criteria: it must be something you've never before given yourself permission to do, and the permission must be given consciously. You must deliberately identify an act, and consciously give yourself the permission to perform it. If you journal, record your responses to the experience; they may assist you in the next challenge.

Pleasure Permissions

I love things that feel good. I'm not the least bit ashamed to admit it – but I'm supposed to be. I'm not supposed to own my pleasure – and neither are you. People who own their plea-

sure are greedy, selfish, hedonistic louts who care nothing for those around them or who they hurt, as long as they get their rocks off, right? Pleasure-centric folk are thoughtless, egotistical jerks with one-track minds, no?

On the contrary. Those who own their pleasure become potent. There's a lot of personal authority in owning who you are; pleasure deprivation is often used by demagogues as a method of control. Convince people that this life is a vale of tears and it's going to suck no matter what they do because they're basically flawed, offer them a better life after this one, and you've got an easily controlled population. Empower people with their own pleasure, encourage them to act based on a strong sense of integrity, and you have a wildly unpredictable and very powerful population beyond anyone's control. Dictatorial systems hate that sort of thing – including the dictatorial systems in our own heads.

Man is not free to refuse to do the thing which gives him more pleasure than any other conceivable action. – Stendhal

I propose a somewhat novel idea: there is no room for unnecessary, misplaced guilt in a world full of pleasure. It's true that some aspects of life are just plain difficult and unenjoyable. Some days, as Tom Waits puts it, "You got to get behind the mule in the morning and plow." There's balance in all things; it's up to us to echo that natural balance within ourselves. In a life where both commitments to work and to pleasure are balanced (intertwined, in the best cases), confidence and comfort become staples. Attending to the responsibilities you've chosen with great care is the balance to permitting yourself a life that includes high doses of joy. Refusing to surrender your pleasure and personal authority is a positive, healthy thing. It makes you a more content, better-adjusted, higher-functioning human being, and that greases all the wheels in life. I refuse to be fodder for the guilt mill; I strongly recommend this happy state of existence to anyone brave enough to try it. It isn't nearly as frightening as it looks.

Owning your fears is necessary. Owning your permissions is necessary. Owning your pleasure is exquisite.

I am a glutton for pleasure; I love finding new things that add to my repertoire. I once thought that pleasure in a scene had to be enshrouded in a layer of complicated props and activities; I was wrong about that. Pleasure can come in a toy bag full of expensive vibrators and whips and other gadgets to be sure, but it also comes in the shape of a rabbit fur mitt, soft sheets, and cold, sweet wet food. For some, pleasure comes in the form of a spanking that leaves the bum rosy pink, being branded (or tattooed), or being kidnapped and "forced." There's no right or wrong way to do pleasure; pain sometimes hops the fence and becomes pleasure itself. You, and you alone, have the right to decide what "pleasure" means to you.

Once you have the general shape of what pleases you, you will have the good fortune of surprising yourself at how many variations on a theme you can compose. There are two general ways to experience pleasure: the physical and the non-physical. There are things that please you outside your skin and within it. In a world of endless possibility, the potential for discovery is boundless.

Sex is nice and pleasure is good for you. – Dossie Easton & Catherine A. Liszt, The Ethical Slut

I have yet to discover all of the things that please me, and I've been at this little quest for a while now; that bodes well for making this a lifelong occupation. I've tried things that looked good on paper and found they didn't suit me; I've tried things that just seemed awful up front, and found depths of delight in them. I am constantly amazed by the fact that I'm constantly amazed. The fewer judgments I have about things being good or bad or right or wrong, the bigger my pleasure potential becomes. The more permissions you identify and grant, the higher your odds for having all the pleasure you can take.

The key, of course, is to experiment, experience, and choose your pleasures. If you try something that has a reputa-

tion for being pleasurable and find you don't care for it, good. You'll have learned that about yourself, and will be able to move on to the next delight on the list.

First, you'll need that list.

Permissions Challenge #4

Trust that still, small voice that says, "This might work and I'll try it." – Diane Mariechild

You now have some solid practice under your belt in identifying your permissions. We did the easy things first for a reason. Now you're ready to tackle something a bit more fierce: pleasure. Pleasure is the response to the things that feel good to your body, your mind, and your spirit. The best kinds of pleasure delight the body, steep the mind in bliss, and send your spirit soaring. The types of arousal best suited to you will most likely do all three. In an integrated system – which we are – it works that way: your mind conceives the happy thought, and if you've chosen it deliberately you've acted in accord with your spirit, and then your body will follow quite merrily along because you've chosen something that will feel good to the five senses. It's a beautiful structure, and we're all hard-wired for it.

Think, for a moment, about what makes you feel good, about what turns you on. A full body massage feels good to most people; that's an existing reality. What if that massage were administered by a group of naked, nubile savages? A group of friends getting together feels good; why not make it into a Dionysian orgy, complete with wine (in very small quantities, please), women and song? A person in uniform is a turn-on for many; how about a big, strong fireman playing with his hose while you watch? With the background you now have, it won't be as difficult to take the things that please you and turn them into material for erotic roleplay.

Whatever your happy thought is, you'll know if it's an arousal trigger; you'll feel the stirrings in your loins. Pay atten-

tion to those little tingles and twitches: that's your body telling your mind that you're on the right track. Do more than merely pay attention to the physical pleasure clues: savor them. Permit your body to feel good while you write down the things that feel good in your head. For the moment, we're again dealing strictly with the realm of fantasy; don't censor yourself. Write down everything that leaps to mind and from there, into your knickers.

Here are some ideas for you:

Being part of a harem – and it's your night to go to the Sultan(a)

Sex in a cave on the beach with the tide coming in

Flirting with/seducing strangers

Being the bully in the class

Being the teacher in a class with a bully who needs to be taught a lesson

A wrestling match between Pan and Jesus in a pool of chocolate pudding

Working in a kissing booth

Being a sacred whore in a Temple

Anonymous sex in a public restroom

A vampire hunting the night's prey

A foot fetishist who works as a shoe salesperson

Go vegetable shopping; whisper in your partner's ear what you'd do with each one

Rescuing a damsel in distress (of any gender)

Shopping for pervertables in the dollar store

Looking for risky places to have hot sex

Kissing someone of a gender you usually don't

Having objects inserted in every major orifice

Being a pirate, courting a haughty Duke's daughter

Nursing a patient

Screwing a professor for an A

Being a big, bad Dom(me) with a dungeon and slaves

Being six and treasured

Passing in public as a member of a different gender

Donna Reed wrestling with Mr. Cleaver to see who gets to
do it with June that night
Mickey Mouse giving you head
You giving Mickey Mouse head
Being a magician with a lovely assistant
Being a rock star with groupies
Sex in the back of a limousine parked on a hill overlooking
the lights of the city
Playing doctor (gynecologist, proctologist...)
69 on the back nine
Being the Minotaur at the center of a labyrinth
Being bound and helpless in layers of plastic wrap
Being in a full body cast with only genitalia exposed
Naked horseback riding

You should now have a list of ideas that will quite easily adapt to potential roles for erotic play. You've come a long way down the paths in your mind; in the next chapter, we'll discuss how to bring others into the amazing realm of your imagination. Before we go there, permit me to offer you what may be the most important permission involved in ER: permission to fail. Without the permission to fall short of an idealized image, one is doomed to fail. Having permission to fail gives one enough wiggle room to make the most of what is, instead of holding an experience up to an impossible standard of what might have been.

6. Communication

Language is the least reliable purveyor of truth – Neale Donald Walsch, Conversations With God

In ER, we need other people to make the really hot scenes happen: a pirate alone is hot, but a pirate with a wench is much, much hotter. Other persons are not automatons; they bring with them their own set of needs, wants and goals; they have images of how they'd like things to occur, ways to make those images happen. They may be in it for head-bending sex, you may need a scene for catharsis. They are, most likely, just as uneasy with being told "no" as you are: they have fears, shames, and dislike rejection. That is an excellent common ground from which to begin communicating – it's something you already know that everyone has in common.

We have one mouth and two ears; that is the ideal ratio for talking to listening. The essential components of communication are listening, listening and listening, accompanied by a bit of talking. Careful listening to both words and how they're spoken help us to discover possible differences and surprising commonalities in tastes and goals. Listening prevents differences from becoming problems. Listening to a potential play partner discuss their abhorrence for face-slapping can show you where possible triggers might be.

Talking about ER – especially with someone new to you – can be nerve-wracking. Attentive listening eases nervous tension in everyone: listening takes you out of your fears and eases

the fears of not being heard in others. Make and keep eye contact; lean in, remain attentive. Words aren't the only form of language.

Feeling unheard is often connected to the ways in which we use language. We all use the same words, but that hairsbreadth of difference in definition can create problems. We all have different "loads" in the words we use; our own experiences and understanding of things does that. "Manipulate," for example, is a word culture has loaded for us; it has the very negative connotation of being twisted to another person's will. Educators refer to teaching toys as "manipulatives"; I use the word to mean movement and sculpting, as an artist manipulates a lump of clay. All uses are valid, just make sure everyone's using it the same way. A loaded word, like a loaded gun, is dangerous. Unloading words, like taking the bullet from a chamber, reduces the danger. If you feel the least bit uncertain about the way a word is used, request clarification. Use your instinct to assist you in this; if you're paying attention, you'll know when something that's been said doesn't feel quite "right." Don't throw the baby out with the bathwater – ask for a definition check first.

What we do in ER is inherently risky in that we open ourselves to others in exceptionally intimate, potentially volatile ways. Erotic roleplay may trigger hidden emotional distress; this should be a conscious risk, kept balanced by the many rewards only play can provide. It's dangerous to assume that, having taken every possible precaution, you've prevented every possible negative reaction – things happen. The only way to avoid the harsh consequences of risk is never to take risks; the downside to that tactic is never reaping any rewards. The more realistic way to minimize the likelihood of unpleasant consequences is to discuss things thoroughly beforehand.

When you do speak, it is best to do so from a clear place of self-understanding; it's my fondest wish that you have a great

Listen, or your tongue will make you deaf. – Native American proverb

deal more information in that vein now than you had before you picked up this book. You can only tell others that which you already know about yourself. Others can tell you a lot about yourself, too, if you're paying attention.

In erotic roleplay, communication can get rather intricate. We can go as far as possible to ensure that we've chosen a potential partner who will be open to trying new things – but when it comes right down to it, we simply don't know how someone's going to take it when we happen to mention that we enjoy wearing a pirate hat and acting like Bluebeard or Anne Bonny, or that we enjoy dressing up like a pony and being put through our paces. There are no guarantees, only honest attempts. Pirates or ponies, communication is the only way to facilitate pleasure when others are involved.

The goal of a scene is mutual gratification.

I want to make what is something of a fine distinction here: there's a difference between mutual gratification and need fulfillment. Mutual gratification is the dynamic of clearly identified desires, expressed thoroughly and with care, stated up front. Involved parties come to the table with different yet compatible desires, discuss how to make those desires happen, and take agreeable, compatible actions to fulfill those desires. For instance: I am, by nature, someone who likes to be in control, and to give intense sensations. I need to express those desires in a healthy way; I desire to do so by enacting sadomasochistic dynamics with consenting others. I know how I'm wired, and I take full, unequivocal, absolute responsibility for getting my desires met by asking for what I want. When I play with someone who does the same thing, we both walk away doing the happy dance, because each of us has assumed responsibility for our personal gratification; we worked together to make it happen.

Need fulfillment, on the other hand, externalizes responsibility by placing it solely in the hands of another. We thereby surrender all personal authority for our own gratification and risk nothing in the bargain, guaranteeing an unpleasant outcome. There's no "risk" involved. It allows us to blame others

for everything if (when!) expectations go unmet. It holds the expectation that an outside source can meet a need instead of satisfying a desire that in turns feeds the need. "Needs" like that usually turn out to be "wants" in drag, as if disguising a want as a need is going to up the odds of it getting it met. Very little communication occurs in a need fulfillment paradigm; it almost always ends in disappointment.

The needs in a need fulfillment arrangement derive from internal difficulties that are beyond anyone else's ability to meet or fix. There may be a need to feel special, worthwhile, or validated. There may be an attempt to patch the gaping wounds in self-esteem with the band-aids of someone else's time and attention (which is similar to treating a sucking chest wound with a four-by-four gauze pad and some tape). Such folks like to avoid the necessity of taking care of self-wounds, of identifying internal discomfort and taking responsibility for it, by dumping all the responsibility on *you*.

No one walks away doing the happy dance after encounters like that.

Without taking responsibility for communicating what you desire to get out of a scene, there's far too much left to chance for you to expect to be gratified or satisfied in any way. Each participating party must take this responsibility for their own gratification by insuring that they do not have unrealistic expectations or unvoiced requirements during the communication process.

ೞ Investment

As an adolescent I aspired to lasting fame, I craved factual certainty, and I thirsted for a meaningful vision of human life – so I became a scientist. This is like becoming an archbishop so you can meet girls. – Matt Cartmill, anthropology professor and author

I believe we all go through feeling that "I did everything I could; there must be something wrong with me. I must be a

bad person." There's a reason for this syndrome of disappointment. When we fully set our teeth to something, wish for it like there's no tomorrow, we're *invested*, usually in the outcome. You're invested if you feel disappointed that something didn't happen or elated that it did.

Consider the oft-cited paradigm of the ham and eggs breakfast: the chicken is involved, the pig is committed. In other words, the chicken added its personal energies to the fulfillment of the breakfast, whereas the pig has invested in – is committed to – its involvement in the meal. In ER, it's better to be the chicken; the pig's investment is one of some permanence. Not much room for flexibility in that kind of investment – it's hard to tell where the pig leaves off and the breakfast begins.

Very few things in life ever turn out exactly the way we planned them; this rule of thumb seems to be amplified in sexual situations involving intense power exchanges requiring openness and vulnerability – like erotic roleplay. Hurling huge amounts of energy at a rigidly defined outcome greatly reduces the likelihood of that outcome and increases the likelihood of disappointment, usually in equal measure.

At their highest octave, investments are what help us make things happen for ourselves. At their lowest octave, they create setups for failure, disappointment and misery. There's nothing wrong with investments in and of themselves – to have the desire and passion to bring something to fulfillment, we must invest some of our energy to make it happen.

I have a pirate fantasy I want to make flesh. Only my idealized images of piratey things will do, or I won't feel enough like a pirate. I'll need the perfect wench: a luscious, buxom redhead, rapier witty, with emerald green eyes and full pouty lips; a kinky Maureen O'Hara would do nicely. I can just see her, standing in a captain's cabin of dark wood paneling, with gorgeous aft windows looking out on a swelling sea. There are candelabras, food and parchment maps strewn about the cabin, and a wider bunk in this cabin than

in any other, topped with a velvet comforter and satin sheets. Trunks spill over with booty. Suddenly, the cabin door flies open; it's my First Mate and a deckhand, with my fiery wench in tow. They throw her into the cabin, she lands on her hands and knees, sprawling before me. She rakes her nails hard enough on the floor to gouge the wood; there is hatred in her eyes. She'd like to punish me. I'm losing control; I'm getting angry. Those things she's saying to me... those aren't in my script! Doesn't she know she's supposed to be a *tamable* hellcat, and not this raging menace? She just keeps coming at me, getting in my face, hurling invective... I can't do this! I'm supposed to be spanking her right now, but I'm afraid she'll kill me if I lay a hand on her! No way am I getting out my knife to cut off her clothes; I'll end up with a slit throat! This is wrong! I did everything right – how can she do this to me in my own fantasy? How dare she screw this up for me! That's it! At least we negotiated safewords, if nothing else; I'm safewording out of this mess! Red! RED!!

That wasn't at all what I wanted; I wanted her to be coolly civilized, independent yet desperately in need of me. How do I elicit that, without getting my eyes scratched out? I can't imagine how I'd ever get my little bedroom to look like a convincing captain's cabin. I seem to have poor taste in wenches, too – there must be something really wrong with her. Even if I did find a kinky O'Hara, what are the odds that she'd be interested in erotic roleplay, let alone in being my wench? This pirate scene was a dismal failure. Maybe this whole erotic roleplay thing isn't such a good idea.

If you don't achieve full replication of the image in your head down to the last detail, misery and self-beratement begin. You have failed, and it hurts.

I don't know of anyone who has managed to eroticize that particular kind of pain.

Let's try it again, without the investments.

I have a pirate fantasy I want to make flesh. I'd love to play with someone kinky who looks like Maureen O'Hara, but that's not what really matters. The right wench for my pirate fantasy will want to be a wench. She'll know where her boundaries are and be able to discuss them with me. She'll be as excited and involved in crafting the scene as she will be in participating. She'll be attractive to and attracted by me – I've got no business playing with someone who isn't attracted to me; they won't like me any better in a pirate hat. There's no way I can make my room look like the cabin image I have in my head from all those swashbuckling films I used to watch. The fact that it would take George Lucas to turn my bedroom into a Captain's cabin won't matter to her; she'll be as willing as I to submerge herself in the fantasy with just the suggestive items I'll use – candles, chocolate coins, my new cuffs. She'll be right there with me, in the Captain's cabin I *can* make out of my room. Besides, she'll know that I'm not really a pirate; she won't expect me to renovate my home for a scene. She'll have enough imagination to use what I have done to hold her in the scene. She'll come in with her own attitude; I can roll with whatever she throws at me – within negotiated limits, of course. If she's catty, I'll be a seafaring dog. If she's kittenish, I'll be the protective hound. I'm good at thinking on my feet. As long has she knows what my hard limits are – and she will, after we negotiate thoroughly – nothing is likely to happen that I can't deal with in role. I can do this!

When you begin to communicate your deepest desires (especially the erotic ones) you open yourself up. You become vulnerable. Culturally and individually, vulnerability terrifies the pants right off of us. It's even more frightening than the prospect of failing – duly so, as it's a precursor to making yourself available to "fail." Failure doesn't really exist. If you had no judgment about having the scene go a certain way, you couldn't fail; you might have even learned a new skill or fact about yourself. We can't fail, but we can certainly tell ourselves that we've somehow fallen short and bludgeon ourselves to pulp with that idea.

Failure is the misplaced judgment that the experience you've just had something other than what it truly was.

You have the power and right to desire, to plan, to hope, to create. You have the imagination and personal authority to get the ball rolling. In order to keep it from rolling right over you, be aware of how much energy you invest in the outcome of any situation; pay attention to how hard you're pushing the ball. Invest in the process, by all means! Go out and buy that pirate hat. Go shopping for the right wench dress. It is, however, extraordinarily ill-advised to script out the entire scene and expect it to go precisely, line by line, the way you scripted it. That sort of rigidity and narrow thinking will allow you to defeat yourself every single time. If you leave yourself room to change on the fly, to improvise, you hard-wire the possibility of a gratifying encounter into your scene. Stop the investment before you put so much of your energy in it that you become lost in a realm outside your control.

It is not because things are difficult that we do not dare; it is because we do not dare that they are difficult.
– Seneca

Investment Challenge

Begin writing out a scene you'd like to try. Pay attention to where you're overly rigid in your expectations; notice where a fuzzy boundary could cause you problems. Pay attention to unwise investments in your own process of creation. What fears come to light?

ॐ Shame

Nobody can make you feel inferior without your permission.– Eleanor Roosevelt

What is it that stops us from actualizing our fantasies, from taking them out of our heads and putting them in our reality? Why do we censor ourselves, conforming to visions of what we should be, or be doing?

Shame is at least as old as groups of fur-covered anthropoids huddled around a campfire or painting on a cave wall. As soon as the group took shape – the whole safety in numbers thing – group dynamics emerged. The welfare of the group outweighed the welfare of the individual, and any individual choosing to join the group had to accept that, or find a cave somewhere else. All in all, this is a sound principle. The mechanism for group governance emerged from the needs of the group itself, each member being a contributor and participant. The rules evolved as the groups did, each apace of the other, creating an entity I'll call the Group Mind.

Then things started to change. Larger groups collected, and individuals began to be born into groups, instead of choosing to join them. There was no longer any checking out the group to see if it was the right one to be in; when you're born into a group, you're in it at least until you get old enough to be able to decide to leave. Even then, you unavoidably take aspects of the group with you. The group and its rules were already in place when you got there, and demanded obedience. The group itself is the governing entity. Each member of the group had a part in its creation, but that creation swiftly developed a mind of its own, over which no single group member held sway. Occasionally, an individual became disillusioned with the Group Mind when it failed to comply with the wants of the individual. Oh, sure, one could always choose to leave the group after reaching maturity, but facing the idea of being outcast and alone after a lifetime spent in a collective family might not seem like such a good idea. No division of labor. No comfy puppy pile of warm bodies in front of the fire. All alone in the big, wide world, without help or helpmeet. Easier to abide by the rules, and just keep going the way you've been taught from birth. Don't rock the boat, and you have hearth and home for the asking. Should you have needs, wants or desires not provided for within the group structure, you could ask to have the needs met (and pray you didn't get laughed or shouted out of the group), or find more subtle, manipulative ways to get what you wanted.

Neither of those options is healthy to the individual or the group; you could be run out of town, or end up getting caught being sneaky and run out of town.

But the group now had something to think about, too: "We need every warm body to make this system we've built work. We don't really want to lose anyone, but neither can we tolerate too much diversity and independence. How do we control the renegades? Can renegades *be* controlled?"

They can't. Slapping additional rigid structure down on an individual already dissatisfied with the group norm is a downright bad idea – makes them more contentious and difficult to manage. The solution? Create a social dynamic that causes them to regulate themselves! Thus was Shame born, to make individuals feel so badly about themselves, should they transgress, that they bring themselves back into line. A simple, elegant, easy and efficient method of control to which all group members succumb if they wish to avail themselves of the advantages of living in a social group.

Our culture emasculates men by not permitting them the depth and scope of their emotive potential. It disempowers women by permitting them only to perform within emotive, nurturing roles deemed "appropriate" to gender. The challenge of defining your Self in your own terms, by your own standards, is difficult at best, shattering at worst. To figure out who we are – let alone what we want – while still participating in the Group Mind is a rigorous and demanding course of action – so much so, in fact, that few make the choice to do so. Unless we know who we are, it's impossible to deduce what we might want, especially in the realm of fantasy. Imagination is taboo, permitted only if used to enhance the roles we're "allowed" by the Group Mind, which we've all helped to create.

We learn shame at an early age when it comes to sex: "Don't touch yourself down there!" "You'll go blind with hair on your palms if you play with that!" "Save it for marriage (or, at least, a good live-in deal)." Our sexual power is always focused outward, on an individual yet to appear in our lives, or on

a set of externalia that will, in all likelihood, never manifest. We're to save it, or to share it only with certain others at certain times under certain circumstances… which is fine. The problem lies in the fact that those criteria are set by others, seldom by the self. If you're a man, wanting sex is fine, and the more of it you get, the bigger a stud you are. Just make sure you don't get your feelings all tangled up in your natural, God-given predatory sexuality, because then you may make yourself open and vulnerable. If you're a woman wanting sex, you are evil, a slut, a whore, suitable for use by only the basest clientele, wanting only what is wanted of you by another.

By deciding to create your own sexual, sensual innerscapes you are, by definition, a rebel. Whether you find you're into leather, feathers, pirate hats or anything other than the missionary position with the lights off – for procreation purposes only, please! – you reject a part of the basic operating paradigm around sexuality. It can be a lonely, foreboding place, that new landscape of rebellion and challenge, featureless until you give it shape and form. The landscape we're given is fully developed: it's like moving into a furnished apartment versus building your own cabin in the woods and planting your own garden with the flowers that most please you. Focusing your power elsewhere, externally, regardless of how compliant and cooperative it makes you seem, deprives you of the available power necessary for creating whatever it is you decide you desire.

Life shrinks or expands in proportion to one's courage.
– Anaïs Nin

Certainly, there's a balance to be had. We've created a structure in which to live and work, a culture. We all feed it with our own energies; it's a composite of every breathing creature living within it. We are also individuals, with individual wants and needs and desires; these things require energy to be brought into existence. If all our energy goes out into the Group Mind, there is none left to create for the individual. If all energies are devoted to the creations of the individual, the Group

Mind collapses, exhausted, offering no protection or safety. The delicate, often fragile balance lies in the ability to maintain one's innerscape while still participating in the Group Mind.

Consider the unconscious ways in which you surrender your power to your own Group Mind. Do you get up every morning, work eight hours a day at a "job" during the week, and then luxuriate hedonistically in some exotic pursuit on the weekends? In what ways do you compensate for the power you surrender to the group?

The first step in conquering shame is to reclaim your power. Internal examination permits the identification of the hidden, subtle things to which you surrender your power *vis-a-vis* what's okay with sex and what isn't. Look at each of the rules you abide by, and decide which ones you're okay with and which ones you aren't. If you've challenged yourself this far, you should be able to meet the challenge of discarding the things that no longer suit you. Once you begin to extract yourself from the tangled web we're raised in, you've gone a long way to reclaiming some of the power that will permit you to go adventuring in your own mind.

> *People travel to wonder at the height of mountains, at the huge waves of the sea, at the long courses of rivers, at the vast compass of the ocean, at the circular motion of the stars; and they pass by themselves without wondering. – St. Augustine*

Connecting ourselves to our own reality, with passion and without judgment, is the anchor that permits us to roam in the worlds of our minds, and then to expand into the innerscapes of others. While we connect and dream and plan, we must remember that we can only be certain of what's inside our own skin; everything outside our skin is unpredictable and uncontrollable. Anything that looks like external control is an illusion; investing energy in an illusion does no more to make it real than walking into McDonalds makes you a Big Mac.

Shame Challenge

Find a place inside where you feel some shame. Where did it come from? Culturally, what is it trying to keep you from doing? Being naughty? Sexual? Vulnerable? Can you bless it

just as much as you bless your kindness, generosity and intelligence? Can you treat it like a good thing?

⚕ Rejection

Though you guard it well,
what destiny does not decree disappears.
Though you cast it aside,
what fate calls yours will not depart.
– The tirukkuRal of tiruvaLLuvar

There's always a chance that we're going to be told "no" in any given situation. Granted, there are degrees: "No, you can't have a cookie" isn't nearly as painful as "No, being a pirate's wench is way too weird for me; take your freakish sexuality issues somewhere else!" The pain factor is dependent on how much we think we desire – want – something, and how much energy we've put into that wanting. Not the desired thing itself, mind you, but the *wanting* of it.

Do not fear mistakes – there are none. – Miles Davis

If we have our hearts set on something, being turned down can be quite painful. If we're certain we've done and said everything possible to hedge our bets on being told "yes" and we still get told "no," it hurts. Sometimes a lot. If we deeply, passionately, intensely, madly desire something to happen and it doesn't, we are crushed, smashed flat under the weight of our own expectations. We feel we have failed. Being told "no" in our culture is somehow a personal reflection of some failure or perceived inadequacy. If only we had done it right, we would have gotten what we wanted. If only we had done, said, thought or been something different, we would have "succeeded." If only.

People say "no" for a wide variety of reasons. If you're told "no," you've been told the other person feels unable to engage with you on the requested level. "No" is not always permanent, either. If someone asked me to do a pirate scene on a day I'd had a fight with my partner, my son got suspended

from school and I had missed a promotion at work, I'd say "no" regardless of how much I love pirate scenes. The asker doesn't hear my bad day; they just hear the "no." Polite inquiries into the cause of a "no" are encouraged; the answer will tell you why the person said "no," precisely what they said "no" to, and whether or not the door is open to ask again later. Develop a philosophy that allows you the grace of accepting a refusal without taking it personally.

Rejection is what we think we face when we present another with some part of us we're afraid they won't accept. People, like animals, can smell fear; the fear of rejection propels us into *re*-actions we might not take were we more centered. It spurs others to take advantage of, or run from, someone who is less than centered. It is our animal nature, and affects us on that level: instinctively. We're not as aware of instinct as animals are; we have been trained to live too far away from our instinct. Nonetheless, we pick up intuitive information constantly and subconsciously; it colors our choices.

There is no terror in the bang, only in the anticipation of it. —Alfred Hitchcock

Some "rejections" hurt more than others. Placed in a framework of personal culpability, rejection is a kneejerk response to "no" that comes from an inadequacy perceived within – feeling bad when the "right" person tells us the "wrong" thing. Rejection happens when someone hits a nail of self-doubt with the hammer of it-just-might-be-true; rejection is a validation of the worst things you believe of yourself. It is easier to feel rejected and blame that feeling on the one who rejected you than it is to consider, deliberately, what is and is not true of yourself.

Like our fear, rejection has its use as a powerful tool: it shows us an aspect of Self that we don't like, don't want to look at and are afraid might be true. When this happens, we can examine the feeling, evaluate it, and decide deliberately if it's true or not; from there we can change it or leave it as our decision warrants. This examination takes courage and the ability

to know when it's time to look inward. The more power we reclaim, the more we have with which to create, and the more we have to share.

Your Saboteur tries to get you to think that by not risking rejection, you're simply avoiding pain, a thing we culturally have decided is "bad." If it hurts, something must be broken, and therefore in need of fixing. Our pain shows us not where we're broken, but where we're tender, awake, and alive. It teaches us to pay attention before we do ourselves any real harm; if it's too late and the harm's been done, it tells us to pay attention to that, too, so that we needn't learn that particular lesson again.

Pain is efficient, necessary, organic, essential. Pain is good. The component to pain that we've added, the accessory to pain that has led most people to assume that pain is bad, is the suffering component. Pain is necessary; suffering is optional. In fact, you can feel anything you like, and not be required to do anything about it other than feel it. In our culture, we feel and knee-jerk react to our feelings. Your knee might jerk in response to a feeling, but that doesn't mean you need to kick someone (especially yourself!). Feelings are not meant to spur us into *re*-action. They are meant to spur us to *feel*; from there, we are to choose our actions – not be driven to them like the chihuahua one step ahead of a stampede.

Your Saboteur tries to convince you that it's doing you a favor by stopping you from stepping in front of the big, scary oncoming stampede. What it's really doing is keeping you from doing anything that might cause change, instigate experience or promote growth. It has become an inhibitor to vulnerability, risk and the pleasure those states can afford us.

Some experiences are meant to be awkward, meant to be painful. We need our awkward moments; they tell us where we're still growing. If you listen closely, it's almost like the sound of a shutter clicking closed on a camera, as a moment is captured in all its awkwardness for a perfect instant in time, frozen in the memory. You hear much the same sound in a perfect moment of bliss.

Next time you feel that fear – of pain, of shame, of rejection – notice it. Notice how it feels, how it makes you feel. The next time you have that feeling, you'll be able to tell where it came from. Notice it, and keep right on going. Being vulnerable is the only way to make contact with others; risking that contact makes our lives bigger, broader, more satisfying. You have the right to risk. If you risk, you may or may not get the reward. If you don't risk, you most certainly will not get any reward at all; unless, of course, bitter loneliness is a good thing for you. (If that's the case, you're set.) For those who seek more pleasant rewards, all that remains is to give yourself the permission to risk, and to be willing to accept whatever occurs as a result.

Take your life in your own hands, and what happens? A terrible thing: no one to blame. – Erica Jong

Rejection Challenge

Describe a situation in which you were told "no," and where that "no" felt like a rejection of who you are. What part(s) of you were rejected? Were you angry? Depressed? Crushed? Write down all of the feelings that came from that rejection. Use them as tools to help you find out what you're afraid might really be true. Are you really too old? Undereducated? Stupid? Look each of those fears square in the face. Talk to them. Discover which of those fears shows you something you'd like to change, and which ones lead you to affirm who you are. Write down the things you feel need some work *and* the things you affirm.

Now go out and make yourself available to be told "no," but be prepared: you may hear "yes."

6. Negotiating

Negotiating is the process of involved parties discussing what's to happen between them, and how. Hard limits – the things in which you absolutely are not interested and will not do – become the lines that delineate the shape of a scene; the activities that are acceptable become the palette of colors with which to fill in the lines.

It is necessary to cultivate some discipline of mind, for an undisciplined mind always finds excuses to act selfishly and thoughtlessly. When the mind is undisciplined, the body is also undisciplined, and so is speech and action. – The Anguttara Nikaya

Negotiating is not bargaining. It is not a matter of "I'll give you this if you give me that," or "I'll do something I kinda don't want to do if you'll do something you're not really comfortable with." Negotiating is not an exchange of desires; it is an exchange of boundaries and information that enables us to fulfill our desires.

Negotiating starts with generalities: "Are you interested in erotic roleplay?" and moves into specifics: "How about a pirate scene?" "What kind of pirate or wench would you like to be?" This can be a very organic process and is so in the best of circumstances.

The desire to negotiate stems directly from an instant of mutual desire. You find someone who shares an interest, and that's where it all begins. You bring with you your desires; they're a part of you. What you negotiate is how the expression of your desires meets and will interact with the desires of another. People with a lot of experience can often conduct a negotiation in a few moments, informally, in the cafeteria. People new to this concept may want to make an appointment to negotiate in an

appropriate place at an appropriate time; the cafeteria isn't right for everyone.

Group scene negotiations happen the same way that one-on-one negotiations do; it's important that all potential players be present for the negotiation session.

A scheduled negotiation can feel like a "first date"; nothing more will happen during that encounter, but it certainly feels a lot like foreplay. You get verbally naked, blunt and vulnerable with your desires; it's pretty hot to be that bare in a public setting – or a private one. It will take a bit longer, but will not be less fun. Negotiating can be the first step in compressing your desire and passion into a flesh encounter.

That compression has a twin: decompression. It is just as important to talk after a scene as it to talk before. Fulfillment is the seed from which new desires spring: nurture your fulfillment. Take note of the best and worst things that happen in a scene; learn from that information. With everything you learn from your highs and lows, things can't help but get better and better, and you get better and better at erotic roleplaying.

No checklist of activities, no amount of negotiation and no safeword will ever be enough if the people themselves are liars, jerks, criminals or fools. – Dr. Gloria G. Brame

However and wherever you negotiate, give yourself plenty of time. Rushed negotiations leave too many holes for mishap to jump through, right smack dab into the middle of a scene. Be clear about your desires. Remain open to "no" and "yes" in equal measure; expect only to find your world a little bigger – whether you play or not. Remember to decompress, and praise each other where praise is due; note your "mistakes," but don't dwell on them.

ᶜᵛ Forms and Formats

I do not believe in reinventing the wheel. Jay Wiseman has covered this material perfectly well and I see no reason to not avail myself of his generosity in consenting to it being used here. It is specific to BDSM encounters and scenes, and re-

quires very little (if any!) adaptation to erotic roleplay. Jay says he's never met a good negotiator who turned out to be a bad player; neither have I. If you'd like to peruse additional negotiation form material, consult the Resources Appendix in the back of this book; the negotiation forms are in their own appendix. Now is a good time to go and have a look at them. What follows is an example of how a negotiation between new partners might go.

Let the Negotiations Begin: A Sample

It was two weeks before our schedules allowed us to meet... during which time my mind had been going crazy with ideas: potential likes and dislikes she might have (none of which I would be able to confirm until we met again), what she would look like nude on her knees before me, the great Pirate Captain, begging for things to be done to her body that, an hour before, she hadn't even known she craved.

But I knew better than to let my dreams and fantasies ruin what was to come. As every gambler will tell you, there's no thrill like seeing a long shot win come home. The cards hit the table and suddenly you're flying first class – or at least your bills are paid for the next few months – all on a pair of fives.

My redheaded hottie was a bit of a long shot. I only know her from the munch group once a month; we've smiled and nodded in passing, but she sparks me. I had to ask; I had to gamble on her. And just as every gambler will also tell you that winning at the table is a game of both skill and patience, so too will every good erotic roleplayer. Especially at the pre-negotiation stage. Now is when investment becomes a real temptation. Now is when it's far too easy to assume too many things, only to be disappointed later, when the real ER cards start hitting the real ER table in all their uncompromising glory.

Remaining uninvested in the outcome was critical, but resisting the investments forming in my mind was equally futile. So I went the other way. I played with each fantasy in my head, enjoyed it thor-

oughly until it burned itself out, then went on to the next. It took the better part of the two-week wait for my head to clear. But by the day of the meeting I was ready. She may have been my long shot win or she may not. Time would tell, and I could honestly say that while I hoped she was, I would be only mildly disappointed if she wasn't.

We had settled on meeting at a local coffee house. It was neutral space. It was usually fairly busy, and so reasonably noisy, but not overly crowded – all facts that would help keep our conversation private.

I brought along a copy of The Form to make sure all the points that needed to be covered would get covered (it's so easy to forget things when you're excited about a new potential scene), and took a seat that offered the most privacy. I hoped this would not turn into a dry interview. From my perspective, how we hit it off today, while discussing the nuts and bolts of our emerging fantasy, would tell me all I needed to know about whether she and I would work well together as we played out the actual scene itself.

She entered the coffee shop, her long red hair swinging loose as she approached the table. Her smile was happy, confident; the prospects looked good.

"Am I late?" She asked, glancing at the clock on the wall.

"No, I'm a little early," I assured her. "Wanted to make sure I had time to find us a table that afforded a bit of privacy. Not quite like my captain's cabin," I drawled with a lopsided grin. "But it's the best I could do on short notice."

"We get to do the captain's cabin later," she chuckled warmly, seating herself. She looked hotter than ever in a forest green sweater and tight black skirt. "This was a good choice. What's the paper about?"

I spun the stapled pages around so she could read them. Across the top it said "SM Scene Negotiation Long Form." She leafed through the pages curiously. "I don't know that we need to run down the list

in order – unless you want to – but I think we'll both feel better about each other's boundaries if we've covered all the points before we're finished."

After a few more moments of perusal, she looked up and nodded. "Okay. This makes sense. We barely know each other right now, after all. Let's start them in order, and see where it goes from there." She spun the pages back toward me.

I perused question one. "Well, for starters, I hadn't planned on recording our scene. Had you?" She shook her head. "Okay. So there'll be you and me. Did we want to try and find anybody else? 'Sailors' and whatever. I was thinking me and thee, so to speak."

Her eyes widened – hazel, thick-lashed. "I don't want anyone else directly involved, no. Though I'll probably have my roommate drop me off wherever we're doing this. Where are we doing it, anyway?"

"Well," I began cautiously. It was a little early to suggest "my place," even though it was the simplest solution. "I live alone," I continued, trying to gauge her reaction as I spoke. "So I don't have roommate concerns, and it's no big deal for me to live around whatever kind of 'set' we come up with for a day or two ahead of time."

She smiled. "Sounds okay to me. I'd volunteer my apartment, but my roommate is studying for her medical boards." Then, obviously sensing my caution, her smile metamorphosed into a grin. "Relax. I'm not going to run out of here screaming just because you say something I can't agree with."

"As you said, we hardly know each other," I smiled back. But I also relaxed a bit. My prospective "wench" seemed well grounded. That boded well for the future.

"Okay, so your roommate will drop you off and then we change, etc. etc. Oh, we'll want to have her phone number handy that night if it's different from the one you gave me." I flipped the papers over.

We paused to order coffee, which apparently gave her time to consider. After the server left, she grimaced. "Can I propose a change to your agenda? I'd rather show up at your place 'in role,' so to

speak. Easier for me to get into and stay in the headspace. Can we begin the scene as soon as I arrive? Maybe my roommate can be one of your 'crew,' escorting the captive princess to your cabin."

It was my turn to grin. "Darling, I don't have this all worked out in *my* head, either. I'm just flinging stuff out there for us to play with. Sure! Be delivered in role. I love it."

"Cool. She won't come in or anything. And the contact number is the same. What's next?"

"Hmm." I took out a business card and gave it to her so she'd have my number to give to her roommate. "Several things spring to mind, but first..." I looked back down at The Form. "Let's see, you're the captive princess, so you're the submissive, I'm the nasty pirate captain, so I'm the dominant. Those roles aren't likely to change," I grinned at her. "So when's show time? I'm a night person, so nine or ten works fine with me, but we can start earlier if you want. After dark would be best, though, for ambiance."

Head tilted, eyes slanted, she slotted me a smoky look through those lashes. "Nine is fine. But do those role assignments mean the captive princess can't turn the tables on the nasty pirate captain? She's used to getting her own way, after all."

I picked up my coffee and sat back to think about that. "Interesting notion," I murmured over the steaming cup. "It'd sure be fun for the princess to try – disappointing if she *didn't* try, but to succeed?" I made a face. "That might get more complicated than we want to deal with this first time together, don't you think?"

"Oh, okay then," she mock-pouted, then grinned. "Next?"

"Segues rather nicely into the next unanswered question on The Form," I chuckled. `Will the submissive promptly obey?' " I quoted. "Doesn't sound like it. At least, not at first."

"Nope. Have to be convinced, of course. More fun that way, at least in this context."

"Agreed," I smiled. "Um... `May the submissive verbally resist?' I hope so! Uh, physical resistance? We haven't talked about that one."

She pursed her lips. "I think *some* physical resistance is expected. A haughty captive princess would not easily submit to being subdued by a lowbrow, gutter-scum pirate, after all." Her voice actually took on cultured, courtly overtones as she said it. "But I don't want to throw us out of the scene, either."

"So you're going to have to walk a line in the scene, and likely so am I. I'd have trouble containing you if you really resisted me, I'm sure," I pointed out. "And if I tried it would probably get messy. End of scene, unless that's where we want to go with this – and I don't. Not on a first date, anyway."

"Ah, no thanks. I'll stick with making it seem convincing. Struggle against my bonds for real, though. That's part of the role, and the fun."

"Well okay, since we're on the subject, let's carry it out a bit further. Pain boundaries. I wasn't really thinking of whips or floggings or anything for this scene, but your lovely hair is just *begging* to be pulled, nipples to be pinched, and of course the haughty princess will probably need to be spanked... " The misty look that came into her eyes at that remark told me I'd scored. "The kind of stuff a rough, uncivilized pirate would do to an insubordinate princess, you know?"

Her expression snapped back into the present, and she cleared her throat pointedly. "Um, yes, I believe I see what you mean," she murmured, sipping from her coffee to recover her composure. "Bare-handed spankings are good for me. And having my hair grabbed is a huge turn-on, too. With the nipples," and here her voice dropped a bit, "gauge it carefully, please. When I'm turned on, I can take quite a bit of sensation there. If not... " Her words drifted off, but she really didn't need to finish, and I was taking notes.

"Ever had them slapped or spanked?" I ventured. "When you're turned on, I mean?"

She glanced around us before answering, nervous at being overheard. "Yes. Bare-handed, again." Her cheeks were flushed. "I'll consent to that, but reserve the right to use safewords, of course. Easy ones – red is stop! Yellow is 'slow down' or 'ease up'."

I nodded and wrote them down in the space provided. "I was going to ask you for those. Actually, I have a leather glove I like to use for spanking."

Her eyebrows lifted. "I'm not so sure about that. One thing about bare hands is that your hands do get sore too, you know?"

"How true," I drawled. "Want to try it out once first, before the scene? If you like it, I'll use it. If not, we stick to bare hands."

That apparently surprised her. "Getting struck once or twice isn't the same as a full-on spanking, and I don't want to be spanked outside of a scene context. But I'm willing to take a small risk, anyway. Go ahead and use it – there are always the safewords. If I find it's unbearable, I'll say 'yellow,' and you can switch back to bare hand to finish. Is that acceptable?"

"Hmm... Well, the safewords are always there for that, but how about this. The point of spanking the princess is to get her to obey, yes? So really, you'll be in control of how much you get anyway. You want more, resist, defy, back talk, blah, blah, blah."

"But what if I do want more, just without the glove?"

"Then you'll have to call 'yellow'," I shrugged, unable to think of any less obtrusive way she could communicate that desire. I could have given up the glove and avoided the potential for disruption to the scene a safeword call would cause, but I didn't want to give up my glove. "A compromise, but I can live with it."

She nodded. "Hey, I haven't had to use a safeword in a scene yet. Take that however you will. What's next?"

I filed that away mentally. It too, boded well. Safewords were necessary safety valves, but their overuse in a scene generally means someone wasn't honest in the negotiations – or someone wasn't listening, like the dominant.

"Well, let's see," I turned back to the Pain section of The Form. "A lot of this just isn't appropriate to what we're planning. Canes,

creams, clamps... Biting. Biting would be an appropriate action for a spoiled princess. Do you bite, my dear?" I grinned toothily at her.

"All us haughty princesses bite," she replied, impudence written all over her. "Especially lowbrow, foulmouthed pirates. Do you bite? And how hard is okay?"

"Only when provoked," I said through a leer. "But no blood; try to bite nicely, won't you?"

She chuckled throatily; the sound triggered all my aural pleasure receptors. "I'll make a special effort, just for you."

"Charmed, I'm sure. Does that mean I get to slap your face?" Now it was getting fun.

"Is that on The Form? Or are you improvising?" She was still smiling, so it was apparently okay.

"Says so, right here," I snorted, voice full of mock indignation. I pointed to The Form. `Face Slaps Yes No.'

She giggled at me. "Provisionally okay, then – no marks, and make sure I see it coming, please."

"I can make sure you see it coming, but you've got a fair complexion. You'll probably get red finger marks if I do no more than grab your chin."

"Good point." Those lips pursed again. It was tempting to lean over and kiss them. I forbore.

"Well, like with the biting thing – light marks are okay, just try not to make it your aim in life, or anything."

"Nothing that won't probably be gone by morning," I nodded. "I can do that unless you bruise easily."

"Not really," she assured me. "No more or less easily than anyone else my age would."

There was another question in another section that also seemed appropriate. "Another question pertinent to slapping you on the

face. Do you wear contacts – or will you be that night?" She nod-ded, sipping her coffee.

"Which is why you want to see the slap coming," I surmised.

"That, and I deal with it better," she said. "The unexpected ones remind me of my slob of an ex-husband. I'm over it," she hurried to add at my look, "divorced him and didn't look back. But I don't want something like that to detract from our fun time if I can avoid it by mentioning it now."

"That's why we're doing this," I smiled. "Well, I think that wraps up pain. How much, how long, what types, and the ancillary stuff that goes with. I turned back to page one. "So let's see. Do you agree to wear a collar? A bit out of place of a pirate scene, especially a short one. Forms of address. I think we can live without that for the most part, but you can call me Sir if you need to call me anything. I dig the genderbend." She nodded. "Well, that takes us to limits, which we've covered a bit. Any special physical or emotional limits I need to know about?"

"I don't do humiliation," she stated flatly.

Now *there* was a loaded word. "Okay," I said slowly. "You'd better define that to make sure I know how you're using the word."

"No verbal abuse like name-calling or belittling. I'm not in this scene to be made to feel ugly, small or worthless." She shrugged, then took a deep breath. "I don't know how else to define it. Got any specific questions?"

"Well," I replied thoughtfully. "Perhaps we'd best start with just why you *do* want to do this scene. What's the big turn on being the fiery princess that gets forced to submit to the big bad pirate?"

"Getting taken out of or beyond myself in pleasure," she replied immediately. "Being overcome by forces outside of my control, find-ing new ways for my body to respond. I can't escape my own skin if I'm being called a fat-assed ugly bitch, or other words to that effect. It just doesn't work for me."

I winced as a vision of her ex-husband abusing her in just such a way flashed through my mind. And right on its heels a flush of anger and

wonderment at how anybody could belittle such an intelligent, lovely woman. "I don't... *couldn't* do that to you anyway," I said quietly. Then I sighed to recollect my emotions and purge the flush of anger.

"So the pirate is a force beyond your control that you wish to drive you to greater heights of pleasure," I paraphrased her to make sure I understood.

She smiled quietly. "Yes, that's it."

"There's a fine line between being forced to submit and being belittled, you know. What if I demand that you beg for me as a sign of your newfound willingness to submit, for instance?"

"I do know – and in that context, begging is okay." She dimpled suddenly. "I'm told I do it rather prettily."

I chuckled throatily, imagining her on her before me, begging. A large, silent part of me groaned with longing. "Okay, let's see... any phobias?"

"A little claustrophobia – I don't do well with full face masks, for instance. Nor being shut in a closet or other airless room. I also do not like rats, not for any reason." She grinned again. "So you definitely don't have to carry realism far enough to import any for your 'ship.'"

"Aww, and here I was going to ship some in from the Caribbean, special, just for you," I grinned back. "Okay, so a blindfold is okay, but not a hood. Any other medical conditions or allergies of note?"

"None."

"And finally, emergency contact info?"

She pulled a computer printout from her purse and handed it over. "All there. How about yours?"

"I'll staple that right here," I showed her the page I was working on. "And mine will be right below it. I have a first aid box that will be in the 'cabin'. I'll put your bag there when you come in so you can see where it's at without us breaking the scene. This form, open

to this page, will be right inside the cover where we can find it at need. Good enough?"

"Perfect. Did we make it all the way through that thing?"

"Nope," I laughed. "Now you get to hear my limits and medical limitations." It didn't take long. "And that takes us to sexual contact. I'm clean," I handed her the STD report I'd picked up from the clinic earlier in the week.

"Genital warts, I'm sorry to say," she sighed, handing me her version which pronounced her clear of everything else. "Bastard ex-husband again. What you choose to do about that is up to you, but I do have a toy bag full of my favorites we can use to minimize the risk to you."

I nodded. "I've got the latex covered – pun intended. So, what's okay and what's not? Shall I read the list?"

"Sure, go ahead."

"Masturbation, fellatio – with a strap-on or dildo," I observed, both of us being female. "Cunnilingus, rimming, anal fisting, vaginal fisting, vaginal intercourse, anal intercourse. Swallowing semen – ah, 'n/a', I'd say. And you're providing the toys. I'd like to see what you've got before we play, though. Food for my fertile imagination."

"Hmmm. Um, masturbation is okay, so is fellatio and cunnilingus (funny word for such an intimate act)... no rimming or fisting of any kind for our first scene together. If there's a next time, we can renegotiate, maybe."

She leaned back, and pushed her empty cup aside. "I'm assuming any intercourse is done with toys, and I won't bring anything I don't want you to put inside me, vaginally or anally. If you want to come by my apartment when we're done here I can show you what's in my toy bag; it's the only real free time I'll have before Friday."

"I've got the time," I replied. "Okay, next a word about intoxicants. I don't like them during scenes. I'll use grape juice for the 'wine.' Can't have a pirate without wine."

"Suits me just fine. What about for afterwards?"

"There will be grape juice left, I'm sure. Other than that, I'm open to suggestion. Champagne and finger foods, maybe?" I grinned.

"You're on," she laughed, then sobered abruptly. "No pot smoking around me, please. I don't know about secondhand smoke and drug tests, but it's definitely an issue."

"Don't have any around anyway," I shrugged. "Okay. We're finally to the end of this thing. Bondage. I've got soft rope suitable for piratey-type use. And I've got some cuffs that aren't too horribly anachronistic. Any ways in which you *don't* want to be tied up?"

After thinking about it, she shook her head. "None of which I am aware," she replied slowly. "But I don't have a great depth of experience with bondage, certainly not with anything exotic."

"I wasn't really planning on getting exotic anyway. Rope, maybe the cuffs," I shrugged. "If you're not worried I'll probably do what feels right at the moment. The only other thing we need to flesh out as far as The Form goes are your safewords. You've got red and yellow. Do you want a third? And we need some nonverbal ones as well."

"Only if you're planning on gagging me. And I'm open to suggestion as to what would work best in that case."

"Hadn't planned on it. It's rather contrary to the idea of the scene. Besides, if I get someone to making all kinds of pretty noises, I want to hear them!" I pushed the now completed Form aside and gave her a sidelong look. "I would just love to cut your lovely princess gown from your heaving breasts... "

"Ooooh... " she breathed. From the color in her face and the interesting peaks under her sweater, that suggestion looked like a definite winner. "I'll be sure to wear something disposable. Probably bought for the occasion. I'm a thrift-store junkie," she confessed. "This gives me a good excuse for another fix. I'll take responsibility for my costume, of course. A friend of mine collects old jewelry, I'm sure

she'd let me borrow some. Maybe go get my hair done up in ring-lets, like in the movies."

Her mouth had assumed a seductive curl. "Does that appeal?"

I shivered at the image of her dressed up in a gown, hair in ringlets, bedecked with bangles and bracelets. "Yes," I replied faintly. "That'll do fine."

The smugness my response elicited suited a haughty, spoiled prin-cess perfectly. "I'm *so* pleased. Unless there's anything else, shall we go? My apartment is on the other side of town, and you wanted to see my toy collection."

"Sure, why not?" I shrugged, then stood up. "We can work out any stray details on the way."

Sometimes you do win against long odds. My redheaded hottie was going to make a wonderful pirate's wench. Our likes and dislikes were compatible, and in general she seemed like an easygoing, fun woman with a good sense of herself. She was very clear on what desires she wanted fulfilled in the scene, and those desires were perfectly compatible with my own. We each had a good chance of helping to fulfill the other's desires.

Section Two: The Flesh of Fantasy

1. Building a Scene

The moment one gives close attention to anything, even a blade of grass, it becomes a mysterious, awesome, indescribably magnificent world in itself. – Henry Miller

A good scene is the act of creating sacred space, a place in which the powerful grapes of fantasy are distilled into the heady wine of bliss.

What does the wineglass that holds that delirious brew look like? In order to hold the image, is a wineglass sufficient, or do I need an entire place setting? It all comes down to how deeply rooted in tangible things you need to be in order for the fantasy to hold water. Do I really and truly need to re-create the captain's cabin, or are there one or two highly suggestive items that will help keep me in role? How in depth do I need to go with character development? Props and costumes serve as substitutes for the psychological connectivity to an image that one might lack. I'd need no props at all to do a vampire/victim scene, because of my personal passions and proclivities; that image is well-developed and resident in my head. I'd need a few small props to do a pirate scene and hold me in it – a little something extra in my peripheral vision to remind me what I'm up to. As medical scenes are not my forté, I'd need practically a whole doctor's office and all the paraphernalia therein to be able to do a medical scene convincingly for myself. The more passion for a scene and identification with a role you have, the greater

the connectivity to the concept, and the fewer material incidentals are required to maintain role.

Grocery shopping is an apt metaphor. I think of something that makes me hot, gives me a tummy tingle or, better yet, a cunt clench. That's the equivalent of being in the right aisle at the store (you can't buy chips in the produce section). I toy with that image in my mind, rolling it around, until other images pop up to join it and a flow happens (that's like finding the right shelf in the aisle for what I'm shopping for). At that point, I have a rough draft for a scene in my head, and I can play it like a movie (the equivalent of having found the exact brand of stuff I went into the store for). I'll roll the tape several times, looking around at the details my subconscious has selected; that list of details becomes my props list. I've found and made my purchase; making it a reality is the act of taking the ingredients home and preparing the feast; doing the scene would be the joyful feasting on what I've prepared.

When I grow up, I want to be a toothbrush! — Carl Chamness, age 4

ᘒ Imagination

We all have an inner voice. Some people hear that inner voice with ease, and can interpret and follow the suggestions it gives with alacrity. I do not happen to be one of those people. Not only have I missed a lot of what that voice has had to tell me, but in moments when it did manage to overcome the din and cacophony and get through to me, I spent a lot of time fighting the suggestions. I had a hard time learning how to play because of that; I kept myself so busy with the creating the obfuscation that I neglected my education and evolution. All of my imagination and energy went into creating reasons why I couldn't do something.

I was very good at creating can'ts. With all that creating under my belt, who am I to say I have no imagination? That's

just another tool my Saboteur uses to confine me to teeny tiny little boxes. I used to claim I had no fantasy life, no imagination – especially in the bedroom. If I had managed to construct and pull off a really spiffy scene, it stuck in my head, as a lovely memory. I then proceeded to shoot myself in the foot by telling myself it was a fluke; it was the other person(s) who really made it happen. Sound familiar?

In retrospect, I cannot say that I wasn't imaginative. It took a lot of creative energy to generate that particular little fantasy – the one in which I have no imagination and nothing whatsoever to do with my own successes. I had to imagine myself as less than I am, and as having done less or differently than I've done, in order for that to work – and that's only a couple of the layers involved in that defeat. I don't know anyone who doesn't sabotage themselves in this fashion.

Luckily there's a balance, a correlate to the imaginative sabotage: the universality of sabotage also means that there isn't anyone who doesn't have an imagination – including you.

No amount of skillful invention can replace the essential element of imagination. – Edward Hopper

Erotic roleplay uses the imagination to create pleasure and beauty in whatever form that takes for you. Culturally, we have a fundamental lack of experience with beauty.[5] We keep it at a distance, hanging in museums, reserved for the artist, the wealthy, the connoisseur. This is an ugly world; things will be better in Heaven. Work hard, keep your nose to the grindstone and when you retire, you'll be able to relax and enjoy the finer things. When it is not denied for us in the workplace or the church, we deny it to ourselves out of senses of guilt, inappropriate feelings of responsibility, shame, strife, and that all-terrible *ought*. To experience beauty is simple; to avoid beauty

5. It's so pervasive a phenomenon, in fact, that there's a word for it: apericolea (a lack of experience with beauty).

takes a phenomenal amount of energy, and a myriad of constructs intended to obfuscate the freedom that beauty permits.

Your imagination is a buffet of beauty. Some of the things you imagine will not appeal to you in real life even though they make perfectly lovely fantasies. You can take some caviar, and leave the vienna sausages on the table; just because they're there doesn't mean you must eat them. This introduces agreeing to disagree: it is possible for two people to both be right about something they disagree on, and no one needs to be wrong in order for that to happen. This principle has further possibilities: you can have something be a part of your imagination, and not act on it. This is you agreeing to disagree with your Self.

Choose something that agrees with you, and begin at the beginning:

Do or do not – there is no try! – Yoda

ᕙ The Beginning

Consider the Prime Triad we discussed earlier. Take something – anything – that is a cause or source of desire for you. It needn't be realistic, or attainable, or anything like it. It needs be only something for which you have a desire. (You should have a list of these items in Permissions Challenge Four.) Look inward to isolate the passion you have for that concept, and then begin to consider ways in which you might bring that to fulfillment. For me, it goes something like this:

Mmmmmmm... Pirates. I like pirates. They wore nifty clothes and had wenches languishing about at their disposal. They commanded rugged individualists with an iron hand. They were fierce and respected, feared, even. They lived on boats and went to exotic ports of call: warm, sunny places with dockside taverns, danger and intrigue. They had swords and other sharp, shiny things. They lived outside the law, or just barely within it, like English privateers. (I prefer, in my fantasy, not to consider the less savory elements of piracy like scurvy or getting drawn and quartered if caught). They

were brave and wicked, riding out storms at sea and on land, mocking the laws of man and nature, emerging only a little scathed (but scathing can give one character, too). They were free and answered to no man or government. They were cruel and vicious – survival mandated that. They understood their world and how to exploit it quickly and efficiently; they got their booty without kissing someone's butt.

This little vignette holds a wealth of information for me. It tells me that I have a desire to step outside rules. I desire nifty clothing that I am not culturally permitted to wear outside my home (unless I'm willing to take the grief I'll get for wearing a frock coat to the grocer's). I desire wenches languishing for me: haughty captive and lusty, buxom tavernite alike. I have a strong desire to own and use many sharp shiny things.

Creation is only the projection into form of that which already exists. – Shirmad Bhagavatam

I have a desire to be a pirate; I'm passionate about rules, clothes, women, and steel.

ᕙ Creativity

Scenecrafting is a creative art, just as much as any of the stereotypic examples are. If you have this book in your hands, I'll bet a sack of gold coins that you're more creative than you think.

We are all creative beings. Before you go poo-poohing, telling yourself that, "Oh, goodness no. I'm not the least bit creative. I don't do the things an artist does!" hear me out. We create every day, individually and as a collective. Every choice we make is a part of the creative process; through choices we create our Selves, our lives, our families, our environments – constantly. Not all of us paint, or sculpt, or write poetry – some of the activities stereotypically ascribed to the creative, artist-type person. Those stereotypes, as stereotypes are wont to do, keep us confined in little boxes that can be very difficult to get out of. What you may not do is to allow yourself to create, to

bring an artistic impulse into being, in the manner that's unique to you. Understandable: we are not exactly encouraged to wander off into the universe of I Can.

To imagine is to create an image of something that is not real or present; imagination is the engine that drives that process. To create is to bring an imagining into reality; creativity is the engine driving *that* process. A fantasy is a product of the imagination that involves fantastic or unlikely elements. When a fantasy is combined with creativity, you have a scene.

Creativity is what brings those luscious and foreboding images into a place where the five basic senses can get at them. I can't make a fantasy image pop up in my head. I must let the images occur; the only making I can do is to choose from the images I'm offered and encourage the flow to go in a direction most pleasing to me. If I wish to be soothed, I'll guide myself towards soothing images. If I want to be hard and wet, I'll guide myself toward the images with the most heat. That, I can control.

People frequently think the creative life is grounded in fantasy. The more difficult truth is that creativity is grounded in reality, in the particular, the focused, well-observed or specifically imagined. – Julia Cameron

2. A Role to Play's the Thing

We play roles in *scenes*. A scene is the interactive session, date, or what have you, from start to finish. It's play and it's The Play. *Scenespace* is a combination of where your body and your head are during a scene; it's the sacred "circle" in which you make magic with your partner(s). To get into scenespace, you need to be in the right *headspace*, or frame of mind. Headspace is the place you go in your mind to become the role you intend to play; it's the place that con-

Play is the exultation of the possible. – Martin Buber

tains that role – and sustains you in it – during a scene. If you think that these sound similar to terms used in the theater, you'd be right. In a erotic roleplay scene, we are performers and audience both; it's a perfect symbiosis. My pirate creates her wench, her wenching creates more piracy in me; my piracy opens up the possibility of greater wenchliness. The cycle is self-perpetuating and exquisitely lovely.

You know you're in scenespace when you realize you'd forgotten, for however brief a moment, that you're *not* really a pirate – or pony, or spaceman. Scenespace is the creation of the players; it's born with both feet under it and ready to run. It is its own entity, created by the energy donated by the players. Like the cycle of player feeding player, the players feed the scene; the scene itself in turn feeds the players: another perfect circuit of energy. Some people play with these power circuits 24/7; full time owner/slave relationships use the circuit of power exchange

constantly. Others find that sustaining a demanding dynamic outside of isolated scenes doesn't work for them. Both dynamics have a beginning (we all must utter the first "yes") and an end (the death of a partner, in some cases); the difference lies in how long the middle is. As we discussed earlier, roles are expressions or facets of Self; the only thing that matters is choosing the role consciously.

❧ Creating the Role

Creating a character and then a role for that character for ER is similar to writing one for a story, or fleshing out a character in a play. A character is the "who" of things; a "role" is the what the character does. You're creating a character that stems from a facet of You, like Athena springing fully-formed from Zeus' forehead. It's substantially more difficult to create a character for a role that doesn't feel like you. It can be done, but choose your roles with care: choose something too distant from the truth of you and you'll have a devil of a time sustaining it. Write down things your character might wear, do or say. Create some familiarity between you and your character; you need intimacy with your role before you can, in role, be intimate with others.

Characters exist within their own context. Thinking about context – culture, time period, family, profession – helps define the character. Within their contexts, they have motivations for the things they do: is your wench poor, motivated by trying to get rich? Is your pirate so bored with wealthy court life that becoming a professional rake is all that's left to alleviate the boredom? Background gives you some access to motive; motive gives you reasons for the things your character does. Reasons give you far more liberty to choose actions. All characters have their strengths and weaknesses, not all of which are immediately apparent,

What lies behind us and what lies before us are tiny matters compared to what lies within us. – Ralph Waldo Emerson

or of immediate use in a scene. Used or not, these traits add depth and color to the character and texture to the role.

A character has consistent vocabulary, dialect and mannerisms that make it identifiable. Pirates swagger and boast, wenches wiggle their bums and have lower-class speech patterns. A character has goals and ambitions; they might not play out specifically in a scene, but your ambitions within a scene will play out into your character and through the scene. As you develop your character, your goal (i.e., to have hot sexy fun) must blend with the character's goals (i.e., to seduce a wealthy pirate into making you his or her mistress).

How elaborate you get with creating a character's background and motives is up to you. How much data about the character do you need to be able to stay in the role? You needn't get too much reality involved; I can't say I know everything about "real" pirates, but I know enough about the pirates that live in my head to create the role with relative ease. Besides, reality is seldom as bright and shiny a thing as the fantasy. If I wanted reality, I'd not bother with ER; I'd find other ways to frolic. What I want is realism within the specific context of a scene; I know, as I suspect you do, how much data I need to support that temporary, fantastic realism. Much of this depends on how well you think on your feet. If you don't improvise well, you'll need extra information resident in your mind ahead of time. If you do well with improv, a name and a few props may be enough to sustain the character and role.

When you're putting your character together, don't look in the mirror, look in your head. No illusions are as convincing as those that play out behind our eyes. Choose something easy to begin with, like a well-known figure from movies or literature – Darth Vader, Ripley, Hamlet[6], Anaïs

6 Shakespeare is an abundant source of ideas for characters and role dynamics; I strongly recommend utilizing his work as a resource. If you can't handle reading the text, several contemporary movie adaptations are available.

Nin. What makes those characters who they are? What draws you to them or the archetype they exemplify? Which of those traits echo your character image? Take apart something you know, and then adapt it to suit the character and role you'd like to see happen. If too much detail, as a known character would have, is a stub to your creative toe, use an archetype or stereotype from history, mythology, fairy tales:

Soldier	Rebel
Nurse	God(dess)
Teacher	Wizard
Witch	Vixen
Hero	Knight
Vampire	Adventurer
Pirate	Child
Princess	Madwoman(man)
Priest	Prostitute
Thief	Victim

True archetypes are hard-wired into us, regardless of culture; stereotypes are hard-wired into us *by* culture. With these images in mind, it's relatively easy to develop individual personalities and motives. Before you know it, you'll be manufacturing characters and their roles out of whole cloth.

You're ready to start adding details. Ask your self questions about this character.

Who is he/she?
What is the family name?
What historical era is appropriate?
What is their financial status?
Did they have a loving family?
Does this character lie? Why and under what circumstances?
Would this character kill another person? Why and under what circumstances?
Are they altruistic, self-centered, egotistical?
Are they generous with friends? With strangers?
Is this character proud? Humble?
Experienced or naive?
Educated or not?

Compassionate or cold?

Easygoing or quick-tempered?

Friendly or reserved?

Loud or soft-spoken?

Glib or tongue-tied?

Etc., if necessary.

There are many more questions to consider, but these will get you started with some answers and, in likelihood, more questions. What do the answers to the questions tell you about your character? How will that information influence what your character does and says in role? By the time you're through the list, you should have a fair grasp of your character, which will help you stay in role during a scene.

Here are some suggestions for ways to play. Don't get trapped in gender issues; remember, you can be anything you want, of any gender you choose! Reversal of traditional power dynamics is powerfully sexy; any of these suggestions also have versatile power dynamics. You get to decide who's on "top."

The creation of something new is not accomplished by the intellect, but by the play instinct acting from inner necessity. The creative mind plays with the objects it loves. – C.J. Jung

Angel/devil

Babysitter/baby

Bandit/victim

Bartender/barfly

Beauty/beast

Bible salesperson/buyer

Blue collar/white collar

Boy or girl scout/troop leader

Caesar/Cleopatra

Call girl/client

Cheerleader/athlete

Cowboy(girl)/Indian

Cowboy/cowgirl

Deity/worshipper

Doctor/patient

Dorky teen/Playboy bunny

Drill sergeant/private

Elf/dwarf

Elf/elf

Enchantress/knight

Evangelist/disciple

Evil stepparent/faithful child

Evil tyrant/innocent subject

Girl scout/boy scout

Hooker/john

Hustler/hustlee

Interrogator/interrogant

Law/lawbreaker
Mad wizard/captive
 princess
Mad wizard/warrior
 heroine
Morticia/Gomez
Nurse/doctor
Oberon/Titania
Penitent/clergy
Pet/owner
Pimp/whore
Pirate/wench
Pony/rider
President/intern
Priest(ess)/sacrifice
Scarlett/Rhett

Secretary/boss
Seductress/prude
Sophisticated (wo)man/
 naïve youngster
Spy/counterspy
Star/adoring fan
Sultan(a)/haremite
Superhero(ine)/rescued
 citizen
Superhero(ine)/
 villain(ness)
Teacher/disruptive
 student
Valkyrie/Viking
Vampire/victim
Viking/warbride

For the extra adventurous, here's some group play ideas. Many of them can be "reversed": several executives and one secretary could just as easily be several secretaries and one executive.

Addams Family group sex
Boy scout/girl scout/
 troop leader
Card game with a flesh
 prize
Cheerleader(s)/sports
 team
Cowboy/cowgirl/
 Indians (and maybe
 even a "horse"!)
Executives/secretary
Gang bang in a bar
Mate-swapping night on
 Mt. Olympus
May Day festivities
 (Beltane)
Mercenaries/innocent
 townsfolk

Military squad/camp
 follower
Mixed gender ship's
 crew orgy
Nurse/doctor/patient
Peanuts
Pimp(s)/whores
Primitive tribal firedance
 orgy
Religious orgy/baccha-
 nalia
Slave auction
Stripper/stag party
Sultan(a)/harem
Thugs/victims
Vampire/victim/vampire
 hunter

∾ Staying in role

If you don't have any acting experience, the idea of be-coming and remaining a character in a scene can be daunting. The temptation to call it off on account of too much silliness or too much effort will be extremely strong at this point. Remem-ber the exercises you did in Section One; stay with the experience until the fear passes, and only anticipation remains. The re-ward for riding it out may well be spectacular.

Rehearse, if time permits. If you can be a pirate in a mir-ror, you can most likely remain a pirate in a scene. No one will criticize your performance as harshly as you. Wear your cos-tume around the house; you'll become accustomed to it, and learn if it impedes any particular types of movement. Speak out loud in the manner appropriate to the character. Try on ges-tures and facial expressions; there may be gestures or looks specific to the character: tossing the hair, raising one eyebrow. Once discovered, these gestures can not only help express the character but to anchor it in your mind. Don't be afraid to laugh at yourself; that's an excellent tension-breaker. Laugh to enjoy, not to denigrate; you want an honest experience with your char-acter, not an experience that will talk you out of even trying. Know enough about your character to be able to think on your character's feet as well as your own. You're assuming a character to play a role; when you enter scenespace, you are that charac-ter and role. Remember that you assumed it in order to play, to have hot, sexy fun.

Falling out of character happens to everyone at some point, especially to those just beginning to experiment with ER. Don't let it throw you if you slip; don't waste your energy casti-gating yourself. Relax, and let yourself slide back into the scene. If you're quick enough, you may be able to use the lapse to the betterment of the scene. I've been so caught up in a role at times that I started laughing at myself out loud (I can only be the Big Bad Dominant for so long before I find myself extraor-dinarily amusing). My victim was startled at the laugh; by

turning it into a low, throaty Laugh of Evil, I bought myself time to slide back into role and managed to make my victim wonder what was coming next. Very rarely is a lapse in role fatal to a scene. Use it to your advantage if it happens — worst case scenario: ignore it and move on with something new and brilliant.

3. Details, Details, Details!

Characters and roles are defined on the inside of your skin; the rest of ER happens on the outside of your skin. It's time to consider the paraphernalia that goes with all of this wonderful stuff. Clothes may make the man, so to speak, but accessories may make the scene. Play with ideas you love; the accessories will follow.

∽ Props

Once I've got an image in my mind of something that appeals, first I consider if I want to bring that into reality. Next, I consider how to do it. I am then faced with options: degree of "realism," with whom I might want to do such a thing, where, etc. To do a real scene, I need to have at least one other person, tools or props as needed, a physical location in which the bodies may engage, blankets, water, necessary material items. Those are not going to coalesce mysteriously from the mists of my mind and suddenly appear. Those, I must use my body to go and fetch. My mind lays the groundwork; my body does the gruntwork – something like this:

How do I bring this scourge of the seven seas to fulfillment? Well, I could use the frock coat I have hanging in the closet – that $12 thrift store number... and there's the kris dagger I got when I graduated from college. I know I have enough clothes to outfit a wench, in high or low style. Am I in a tavern or on a boat? A boat. The captain's

cabin, of course. My mixed-gender crew is singing rum-induced bawdy ballads up on deck; they're so far into their cups that the screams of my kidnapped heiress or resisting doxy won't be of the least remark. I'll need music or ocean sounds for background. Drapey sail type things on the walls would help hold that image in place... maybe some shackles. A large jeweled goblet of a fine pilfered beverage. Semi-darkness, with candles or torchy things casting eerie, slightly menacing shadows on the walls. Sacks of gold coins and jewelry will be scattered about, reflecting the candlelight in twinkling mounds.

The pictures in my head gives me a props list, which looks like this:

role-suggesting clothes for me and my victim
a favorite piece of steel to strap on my belt
a sheet on the wall or over the windows to imitate sails
a CD of traditional seafaring tunes
a cheap pair of goblets I got at a thrift store and glued colored rhinestone on
ambient lighting
a bag of those chocolate coins (sugar is good for afterwards)
some sparkly costume jewelry

I can pare or enhance my props list at will, depending on how much time, effort and money I wish to invest in creating a captain's cabin out of my bedroom. Having at least one prop for sight, smell, taste, touch and hearing is a good anchor point for willing suspension of disbelief. You can always add props specifically targeted at each of the five senses, but one each provides the foundation upon which one may build.

Props don't need to cost a fortune. A great place to start looking for props is your kitchen. Instead of looking for a pervertable[7] item, look at each item in the kitchen, consider its potential and ask yourself, "What sensation would this item

7. Pervertables are mundane items that have scene adaptation potential.

inflict? What does it look like it could be if used as a prop? For what functions other than the intended could this be used safely?" Many of the items you handle every day without giving a second glance make excellent pervertables. I am not suggesting you torment your lover with the barbecue grill brush one night, then use it to grill the next. Use the items you already have to give you naughty ideas, then buy a dedicated version of that item to keep in your toy box, bag or drawer. If you absolutely must use an item you already have, *clean it exceptionally well first with antiseptic, antibacterial soap! If it's boilable, boil it!*

Spatulas, tongs, and skewers are all quite versatile. Look in the freezer; do you have any popsicles?[8] Plastic wrap is good for more than covering leftovers, and it comes in colors; pallet wrap is even sturdier. Be sure to check your bathroom as well; you'd be amazed at the sensation range of a toothbrush. How about your tool box? Duct tape is one of the most versatile substances on the planet. Silk scarves and/or stockings make great blindfolds – especially if you put something else on the eyelid, under the blindfold. Silk feels good on the skin as well – you get tactility and function. Telephone cord does not work well for bondage; it breaks too easily and is too narrow for safety.

If your home does not provide you with all the props on your list, explore thrift stores; they're often a bountiful and inexpensive props department. They're a great source for clothing you wouldn't mind having removed with scissors or a knife. Dollar stores are also treasure troves for props; a $10 scene budget is usually more than enough, and you can re-use the props later – it's called plausible deniability. Yard sales yield unexpected delights; estate sales are wonderful for vintage clothing and scenery. I'm eroticized to home improvement and hardware stores; just seeing one makes me wet. Pet shops are highly

8. Being phallic, popsicles have insertion appeal. Being cold, they have sadistic appeal. Being sugar, they have a yeast infection risk in a vagina. If you use one on a woman, put it in a condom first. And don't insert one into the anus of a person who has a heart condition – doing so can sometimes slow the heartbeat dangerously.

entertaining, as are farm supply stores. For military items, check army surplus stores; contact your local Boy Scouts to find out where they buy their uniforms (which adapt well for military scenes). Uniform stores are excellent sources for medical-looking clothes; religious supply shops and catalogues are fascinating.

Borrow from friends; they don't necessarily need to know what you're going to do with that paddle-shaped cheese board. Only borrow items that can be returned in the condition they were received. Never, never underestimate the potential of cardboard boxes and a magic marker. Some temporary hair dye or a wig can go a long way to putting you more firmly in your character: little differences can make a big difference. Once you start paying attention to the possibilities in everyday things, you'll be amazed at how your imagination expands; it becomes a habit and you'll see potential pleasure everywhere. Developing that habit will be of far more use to you than any specific list of places to get things. Check the Resource Guide for specialty and toy sources.

Like an ability or muscle, hearing your inner wisdom is strengthened by doing it.
– Robbie Gass

Props don't need to be a particular thing; they just need to resemble it closely enough to hold the image of the fantasy you're creating. Conduct your investigation with a friend – two heads are often more fun than one. If you want great ideas for kinky toys on a budget, consult the Resources section.

❧ Environment

The room should be warm enough for the person who'll be wearing the least amount of clothing. Make sure your equipment – whatever it is – is conveniently located; fumbling for toys and tools is a terrible distraction. Too many distractions and you'll break the mood you've gone to great lengths to create. Light should be strong enough to see by; too dim, and you won't be able to find tools no matter how conveniently you've placed them. Lighting is essential to setting the tone of a scene

(lots of light for medical, but not so much for pirates). Let the theme dictate the lighting. Be careful using candles; it's easy to get distracted and forget about them – there are many inexpensive lighting devices on the market; check your local novelty store or mall.

Music is a critical environmental element, both what is playing in the background and what isn't. Sometimes silence and the breath of pleasure are all the orchestra you'll need. Musical tastes vary wildly from person to person; there's an appendix in the back of the book with some suggestions for music that can work well in a scene. Some people are distracted by words; others find that if the words are fitting, they enhance the scene. Learn what works for you. If you're playing with someone who can't stand music in a scene, and you can't do without it, I suggest headphones. If you go that route, or if you like your music loud enough to preclude ordinary communication, be certain that you have a non-verbal safeword in place.

Music isn't just good for background; it can become a tool used within the scene – for pain as well as pleasure. I was recently told of an entire scene done to Prince's *1999*. Choreographed to each song, the scene used the music as a torment device. I happen to love Prince, but that would have been just too much for my sadistic self.

If you choose to do an outdoor scene, check the weather reports the day before: a sudden squall can dampen the mood. Check and double-check your gear – it's awful to have left that special rope at home, with that tree just begging to have someone tied to it. Make sure you have permission to be on private property; be cautious in your exposure choices if you're using public lands. Are you willing to face the possible consequences for tying someone to a tree in a park, or getting caught having sex in a public restroom? It's risky, but it's a rush; just make sure the rush is worth the possible consequences to you.

4. Playing Out the Scene

*The world of reality has its limits; the world of imagi-
nation is boundless. – Jean-Jacques Rousseau*

The preparation for a scene is gratifying. It gives me a
chance to relish my own enthusiasm and excitement, to build
more detailed images in my mind. It's the revving of my en-
gine, the heightening of anticipation, a form of foreplay. Doing
the scene is what fulfills the promise of my anticipation. I often
surprise myself in a scene; the unexpected appears, wearing a
waistcoat and watch chain. I follow it down the hole and am
never disappointed.

It can be difficult to just leap into a hole, though. It seems
dark and scary down there, and you definitely can't see much –
until you're in it. That's the secret: there's always something in
there to see, the likes of which you probably never dreamed.
Our conscious minds do the bulk of the work in setting a scene,
but the unconscious mind is willing to add its two bits once the
ball starts rolling. Don't be afraid of the unknown jumping into
your scene with you. If you fear it, it will stop you dead in your
tracks. Notice that you feel a fear coming on, and embrace the
opportunity it gives you to think on your feet. Go down that hole!

You are The Alchemist, turning lead into gold. You are
The Magician, complete with Lovely Assistant, ready to make
the real world disappear and a fantasy appear, right before your
very eyes. You are God, creating an entire world for your plea-
sure. Remember what God had to learn the hard way: what

you're creating will have a life and will of its own. People come together in a scene, but between them, they create a separate entity: the scene itself. That creature, that entity, may have ideas of its own as to how things should go. If you fight that, you'll have a mess on your hands. If you follow it, waistcoat, watch chain and all, you'll be amazed.

The stage is set; all the players know their roles. Since it's improv, there's no script – nothing to forget to say or do. It's free-form from here.

My bedroom is a captain's cabin. I have my purloined heiress in my clutches, happily terrified and willing to be unwilling. I intend to open her treasure chest and claim all of her treasures as mine. I growl, low throaty pirate noises. I circle the chair to which she's bound, not touching, but obviously making a very close inspection of her assets. I make her feel naked with my penetrating stare. She trembles. She wants me to ravish her. I can smell it on her. But I will not. I will make her want me; she will beg for the ravishment she so desperately needs. I will make her see her own lust, bring it to stand naked before her. She will confront her wanting and I will make her beg.

I reach to stroke her cheek; she turns her ahead way from my touch. I chuckle in an evil and menacing fashion.

"So, my lovely, you think you do not crave my caress."

"I'd sooner be touched by a leprous dog!"

"That can be arranged; shall I summon the first mate? Perhaps his tender ministrations would help you to relax."

"I care not what you do," she says haughtily, as if I am a waste of her words.

"Then you will not mind if I leave you to the mercy of my crew. They may command more of your attention than I do seem to."

With a bold and defiant stare, she says, "As if you would! Do you think I cannot smell your desire for me upon you, stronger than the

foul reek of the sea and this ship? I may be bound to this chair, captive, but in this cabin, I know who wants whom."

I hide my flustered doubt about what to say next behind a loud and uproarious laugh. I stall for time. The wench has met me on my own ground; the gauntlet is thrown. I revel in the challenge.

"HA! Oh yes, my dear, you certainly do know how wants whom." I reach under her skirt to find a warm, wet denial of her callous words. Her breath catches somewhere in the heaving of her bosom. I withdraw my hand, savoring the scent of her juices on my fingers, raising my desire another notch. I lean in close, her eyes unable to turn from mine, and say, "This boat is not the only thing that smells of the sea."

She is offended, as I intended. Scornfully she says, "Only an unlettered ass would mistake fear for desire."

"Then you must desire the fear, princess, for your body betrays you."

"Perhaps," she says, "but I do not desire *you*."

I am amused. I grab her by the hair at the nape of her neck, pulling her mouth within kissing range. I kiss her; I can feel her coldness begin to melt. My other hand drifts towards a hard, upthrust nipple. I roll it none too gently in my fingers. Her moan fills my mouth with a song of passion. I end the kiss; her eyes snap open, filled with the terror of knowing that she has lied and been caught. I am the object of her desire; she knows that we both know. She has surrendered, and the field of victory is mine to play upon. She whispers one word:

"Please... "

❧ Aftercare

A painting is never finished - it simply stops in interesting places. – Paul Gardner, painter

You've just had an amazing experience. You are disheveled and spent, and floating back down to the "real world" from the Forever Place. What now?

I take care of my toys – playthings and playmates – if I expect to use them again. A thing can be replaced; a mate cannot. Just as fulfillment plants the seed of new desires, aftercare plants the desire to play again. It closes the circle, completes the circuit of energy exchange. Aftercare is quite comforting and congenial, as well; it is a pleasing, unique, fun way to create intimacy. It is just as much a component of ER as is everything else.

In erotic roleplay, we play with the body and mind together. A great deal of fantasy happens in our heads, but our bodies act it out. When we're aroused, our bodies go through changes: blood pressure goes up, adrenaline flows, endorphins rush. These chemicals in our system create states that have consequences: they're intoxicating. Blood sugar levels zoom during a scene, even more so if heavy sensation play is involved. After the impetus to zoom is removed, the blood sugar crashes. This can manifest as dizziness, trembling, hunger, giddiness or, in worst cases, nausea or fainting. Those cases are usually associated with heavy pain play; if you're just doing a little slap-and-tickle, it shouldn't be an issue.

The worst consequences of a sugar or endorphin crash are largely avoidable. Have the affected person lie down if they can, and just rest awhile. It's not wise to force someone to come back from the Forever Place too quickly. Keep warm blankets nearby, and have plenty of water on hand. Bundle them up if their skin is chilled, and encourage them to drink. Fruit juices are excellent for alleviating sugar crashes; candy works too, but isn't as easy for a body to process. Protein and carbohydrates also help restore a person's system to normal operating parameters. Encourage eating when they're ready; forcing food on a queasy stomach can result in vomiting – no one wants that as the closing image to a scene. You should have smelling salts in your first aid kit (see the Safety Appendix) in case someone does faint. If you are unable to rouse a fainter to consciousness within five minutes, seek medical assistance.

It's a good idea to keep your CPR/First Aid training up to date; I always ask a potential partner if they're certified in either/both. Just because I'm the dominant one doesn't mean something isn't ever going to happen to me; I prefer to know I'm in capable hands should an emergency arise.

Physical emergencies aren't the only types that can stem from an erotic roleplay scene. When you start shaking the tree, you never know what's going to fall out. The human psyche is an elaborate, intricate thing; though you've negotiated in order to avoid known triggers, sometimes people don't know where all of theirs are. If they don't know, they can't tell you. An unexpected slap to the face could be a trigger for suppressed childhood issues; suddenly your wonderful scene becomes a relived trauma. Something may fall out of their tree during or after a session (it can take weeks, sometimes). They didn't know a trigger was present, it's a no-fault situation. In any case, treat other people's emotional issues with the same attention and care you'd like to be given.

Immediately after a scene, spend some time being intimate out of role, snuggling. Take your time; never rush aftercare. Talk. Whisper. Giggle. It's not generally best to discuss the scene immediately afterwards. Both of you should still be flying from the experience; that's not a great headspace for talking or, more importantly, listening. If it will keep until the next day, let it wait. For now, be sensitive, loving and attentive. The important things will come up.

Be just as willing to accept praise for your work in a scene as you are to accept criticism. We learn just as readily from what we've done "right" as what we've done that didn't work so well. "Thank you" is the appropriate response to a compliment on your efforts.

The rules of thumb for aftercare: keep warm, drink lots, eat when you get hungry, don't try to debrief immediately and enjoy the company of the magnificent being who just helped you make a fantasy flesh.

That's a Wrap

Amazing what the human mind can do with a bit of direction and inspiration, isn't it? I hope you found some delightful new rooms in the mansion of your mind; I wish you joy in exploring them. Self-exploration is a life-long process; may you continue to make discoveries and revel in them.

This book has been an amazing journey for me. I learned a great deal about myself in the writing of it; I hope you garnered some personal riches in the reading of it. Now go out there and play: play smart, play fair, play lots!

Appendix One: Safety

This information is covered in other texts in the Resource Guide; I include a note on it here, just to be safe.

It's silly to assume that every precaution has been taken for any activity, especially ER. Even with risk minimization, stuff happens. Take on the role of Scout, and be prepared.

Your basic safety kit should include:

Flashlight (check batteries before each scene)

Larger emergency light in case of power failure

Fire extinguisher

First aid kit (build your own, or buy one pre-assembled)[9]

Paramedic's scissors (they cut through almost anything in a hurry, and are blunted on the ends to prevent accidental injury)

Each player should know where a telephone is. Leave contact information – address and phone number – with someone you trust. If you're playing for the first time with someone new, set up a "silent alarm" – a signal delivered by phone at a designated time to indicate all is well. If you don't use the signal or miss the call entirely, your alarm person should notify law enforcement.

If law enforcement or emergency medical becomes involved, you may be tempted to run about the house tidying up. The injured person should be of primary and immediate concern. You are not doing anything wrong (and hopefully nothing illegal); you have nothing of which to be ashamed. If they look

9. For help in assembling a first-aid kit, contact the Red Cross.

at you askance, it may well be jealousy or simple curiosity. Be polite; that seldom gets anyone in trouble.

Appendix Two: The Compleat Pirate

Have you the lion's part written? Pray you, if it be, give it me, for I am slow of study. – William Shakespeare, A Midsummer Night's Dream

To illustrate how a scene might go down from start to finish, I've recorded this little memoir.

Monday, evening

Just got back from the munch – I have a play date two weeks from Friday! The hottie I've been lusting after at has finally noticed me, and she's into erotic roleplay too! She's amazing; I hope I look that good when I'm 40.

She said to figure out what kind of scene I'd like to do, and then give her a call. Hmm. What would I like to do? She's not into vampires much, and even though she'd make a cute little girl, that's not where I'd like to go right now.

Mmmmmmm… Pirates. I like pirates. They wore nifty clothes and had wenches languishing about at their disposal. They were fierce and respected. Feared, even. I want to be fierce and respected. They lived on boats and went to exotic ports of call; warm, sunny places with dockside taverns, danger and intrigue. They had swords and other sharp, shiny things. They were brave and wicked, riding out storms at sea and on land, mocking the laws of man and Nature, emerging only a little scathed (but scathing can give one character, too). They were cruel and vicious; I want to be cruel and

vicious. They understood their world and how to exploit it quickly and efficiently; they got their booty without kissing someone's butt. She definitely has booty I'd like to plunder and she'd make a stunning, sexy princess, with that curvy figure and all that long, red hair; I'd cut a dashing figure in a pirate hat… pirates it is!

Tuesday

I just called her; she said "yes" to mischief on the high seas! Good thing I have a waterbed for wave simulation. We're meeting next Wednesday for coffee and negotiations.

Next Wednesday, late evening

The negotiations went well; our limits are similar, and we enjoy a lot of the same kinds of sensation. She's going to look adorable with her skirts up over her hips, laid across my knees for a spanking. She was excited about going shopping for her outfit. She says a friend of hers collects old jewelry she could borrow, and she might even have her hair done up in cascades of curls, just like in the old swashbuckling movies. All that, just to be my wench – damn, I'm lucky! We agreed that the scene will start as soon as she's in the door, so she'll have to do whatever it is she does to put herself into scene space before she gets here. She'll have her roommate drop her off as a "crew member" delivering her to the Captain. Her roommate will also know where I live and where she is – she's smart to keep herself safe that way, especially since this is our first play date. I'm no risk, but I know there are those who do inappropriate things to unwilling people out there. I'll take her home if she decides not to spend the night. I hope she does decide to stay, but if she doesn't, I'll have something to look forward to another time.

I only have two days – I gotta get ready!

How do I become the pirate of her dreams? How do I make myself irresistible and sexy? Well, I could use the frock coat I have hanging in the closet – that $12 thrift store number, made of black watered satin with the purple lining… and there's the kris dagger I got when I graduated from college. Will we be in a tavern or on a boat? A boat. The captain's cabin, of course. My mixed-gender crew is singing rum-induced bawdy ballads up on deck; they're so far into their cups that the screams of my kidnapped princess won't be of the

least remark. Drapey sail-type things on the walls would help hold that image in place... maybe some shackles. A large jeweled goblet filled with a fine pilfered beverage. Semi-darkness, with candles or torchy things casting eerie, slightly menacing shadows on the walls. Sacks of gold coins and jewelry will lie scattered about, reflecting the candlelight in twinkling mounds.

I can borrow the pirate soundtrack from a friend. I have some old white sheets I can hang over the windows so that they billow in the evening breeze. Those fake torches, with the fabric and light bulbs that imitate flame, will be safer than candles; I won't have to check to see how far they've burned. I have the brand-new cuffs I haven't even used yet, and plenty of Nana's old costume jewelry.

I guess all I really need are some chocolate coins; the sugar will be good for stabilizing metabolism later. I think I'll get some grape juice for the goblets; that'll be good for afters, too. She's not vegetarian – maybe a small tray of meat and cheese, some crackers, something like a tray of food a captain would have laying about would be good. Protein is important after a scene. I have plenty of water bottles in the fridge, and I'll remember to put some in the room. Can't let a princess get thirsty, now, can we? I am chuckling to myself – I'm having a ball with this, and she's not even here yet!

Friday afternoon/evening

Okay. Everything's in place, as far as I can tell – and I've checked three times. Funny, how I've gone from housekeeper with my hair in a bandana mopping the floor, changing the sheets, vacuuming the carpet, to the Captain of my very own pirate ship, in just a couple of hours. I should go over everything again, just to be safe. I don't mind some surprises, but I do prefer to minimize the potential. Cat door is closed, and they're all outside. Ringer's off on the phone; answering machine volume is as low as it goes. Plenty of water, easily accessible. A warm blanket to wrap her up in after; those endorphin crashes can be intense. All my first aid and safety gear is in the old chest I found while I was shopping for boots. The heater is set to be warm enough for a naked person. Lube and latex at the ready; she said she'd bring her favorite sex toys, so mine are stowed. Heh! Look at that – I'm even talking like a pirate to myself! I don't know

if I'm getting into the role, or the role's getting into me. I don't think it matters much, to tell the truth. Whatever it is, it's working beautifully.

She's here. Ohmigawd. She's here. She must be giving the phone number to her friend – good. I already have her contact phone number on the negotiation form. She's coming up the walk... I can't quite see... oh, sweet Jeebus! How did she manage to put together a princess outfit like that from clothing we agreed should be disposable so I could cut it off her body? She's so dignified, so regal, so... delicious! I hope she can't hear my heartbeat from there; my pulse is going faster than the high setting on my vibrator... she's breathtaking. I can't let her see me all flustered; I am the fearless, commanding Captain! Nothing ruffles my feathers! I am cool and collected – no I'm not, but I think I can make it look like I am. I can be convincing. I can... oh, just shut up and be here in this moment! Must calm self before opening door. Must calm self before opening door. Must calm self...

I am soooooo ready for this.

I've closed the door, and the wicked intent in the cool smile she flashed at me is enough to give me goosebumps. I *am* a pirate captain, and she **is** my abducted princess. I show her into the captain's cabin my bedroom has become. I have my purloined princess in my clutches, happily terrified and willing to be unwilling. I intend to open her trove and claim all of her treasures as mine.

I take her bag with toys and a change of clothes and set it down next to the chest with the first aid kit in it, making sure she sees where I've put it.

"Good evening, Highness. Won't you be seated?"

"I prefer to stand."

"As you like – for the moment." I pour some "wine" into a goblet, offering it to her. Her spine stiffens a notch; her chin rises in disdainful rebellion. "I am not thirsty enough to drink whatever swill you think to serve me."

I salute her with my goblet, downing the entire contents in one swig, wiping my mouth on my sleeve. "Ah, a fine vintage, from your father's own casks, Highness. But as you say, you have not thirst enough as yet. Spoiled as you are, I'm sure there's little that could satisfy so refined a palate. Perhaps my brand of kindness is wasted on such a spoiled creature as well."

She flinches. "What does a rogue know of manners? You, Sir," the sneer in her voice thrills me, "are a blackguard and a ruffian. You have nothing that I could ever want. Please have me escorted to my cabin, and let us have done with this nonsense. My father will ransom me quickly, and we need never see each other again."

"But, Highness, your father's coffers don't interest me in the slightest. He has something of so high a worth that no ransom could meet the price." I nonchalantly pour more "wine."

Impatiently, she asks, "And what might that be, you greedy heathen?"

"Why, his daughter, of course." The shudder that courses through her is enough to tell me that I've said exactly the right thing. I am encouraged to continue. "Such a priceless treasure will stand me in good stead once we reach port; with you in my inventory, I'll want for nothing."

As any good princess would, she bolts for the door. She doesn't make it. I grab her arm, spinning her into my embrace. She struggles a bit, as we agreed she could, but offers no true resistance while I buckle the cuffs on her wrists. She wriggles enough to hold the illusion but not enough to make my job difficult. I stand her, cuffed hands bound behind her back, in front of the chair. Taking a step back, I look her up and down. I shrug, as if to say, eh; she'll do. I shove her backwards, into the chair. I make it look rough, but I pull my shove at the last second. Her mind will register the way the shove appeared well before her body will register that she wasn't shoved very hard at all. The impact is mostly mental, as I intended.

Before she can try to scramble out of the chair, I'm behind her, tying her hands to the chair. She can struggle against her bonds all she wants; we agreed on there being no wrestling matches tonight. But struggle she does, and quite beautifully. She begins to make little noises of frustration; it sinks in that she's not going anywhere.

I growl, low throaty pirate noises. I circle the chair to which she's bound, a leisurely stroll about the cabin, my hands clasped behind me. I don't touch, but obviously make a very close inspection of her assets. I make her feel naked with my penetrating stare. I feel goofy for a second, thinking that, but her trembling rewards my efforts, and my momentary lack of confidence fades.

She wants me to ravish her. I can smell it on her. But I will not. I will make her want me; she will beg for the ravishment she so desperately desires. I will make her see her own lust, bring it to stand naked before her. She will confront her wanting and I will make her beg. *Oh, the sweet rush of power!*

I reach to stroke her cheek; she turns her head away from my touch. I chuckle in an evil and menacing fashion.

"So, my lovely, you think you crave neither my wine nor my caress."

"I'd sooner be touched by a leprous dog!" Her anger arouses me.

"That can be arranged; shall I summon the first mate? Perhaps his tender ministrations would help you to relax."

"I care not what you do," she says haughtily, as if I am a waste of her words.

"Then you will not mind if I leave you to the mercy of my crew. They may command more of your attention than I do seem to." In this moment, we both *believe* there is a crew, waiting for my commands. *The gambit works.*

With a bold and defiant stare, she says, "As if you would! Do you think I cannot smell your desire for me upon you, stronger than the foul reek of the sea and this ship? I may be bound to this chair, captive, but in this cabin, I know who wants whom." She tosses her curls, as if bouncing red hair could convey her superiority.

I hide my flustered doubt about what to say next behind a loud and uproarious laugh. I stall for time. The wench has met me on my own ground! Of all the things I had in my mind that could happen, being

rendered retort-less wasn't one of them! The gauntlet is thrown. I revel in the challenge. Moving slowly to give myself time to think, to respond, it comes to me.

"HA! Oh yes, my dear, you certainly do know who wants whom." I reach under her skirt to find a warm, wet denial of her callous words. Her breath catches somewhere in the heaving of her bosom. I withdraw my hand, savoring the scent of her juices on my fingers, raising my desire another notch. I lean in close. She cannot look away; I hold her eyes with mine. I draw my damp, scented fingers beneath her nose. Softly, I say, "This boat is not the only thing that smells of the sea."

She is magnificently offended, as I wanted. Scornfully she says, "Only an unlettered ass would mistake fear for desire."

"Then you must desire the fear, princess, for your body betrays you."

"Perhaps," she says, "but I do not desire *you*."

I am amused. I grab her by the hair at the nape of her neck, pulling her mouth within kissing range. With that kiss, I feel her coldness begin to melt. My other hand drifts towards a hard, upthrust nipple. Her body is taut; she no longer fights me, but herself. I roll her nipple none too gently in my fingers. Her moan fills my mouth with a song of passion. I end the kiss; her eyes snap open, filled with the terror of knowing that she has lied and been caught. I am the object of her desire; she knows that we both know. She has surrendered, and the field of victory is mine to play upon. She whispers one word:

"Please... "

A throaty chuckle and a peck on her freckled nose incense her further. She tries to act dignified, but it is too late. I have revealed her own wantonness to her; I become referee for the battle inside her. I know which side I want to win.

"Excellent, Highness. You are proving to be most compliant. You have done what I wished: you have asked for something to begin. Now I will teach you to ask for something to cease." I draw my kris from its sheath, making sure the light glints off the blade. I trace the

tip behind her ear, down her neck, across her shoulder. Anticipation and arousal in equal parts flush her skin; she arches slightly to meet my blade. She has nothing clever to say; her body speaks a language in which I'd like to become fluent. I begin separating her lovely ensemble from her skin until only a layer of warm air separates her skin from my hand.

I don't resist touching her; I don't have to. She's mine now. I take my time; I want to memorize the way her skin feels. I savor touching her everywhere, from feet to hair. I don't touch the one place I know she'd like it most. I get close; a knuckle brushes her labia as I caress her thigh; she leans towards my hand. I'm saving that for later. As I reach for her breasts, she shies away. I tweak her nipples hard enough to elicit a gasp, pulling suddenly away. She growls at me; it's a low, guttural noise. It makes me smile. I fill my hand with the hair at the nape of her neck and kiss her until we're both breathless. She resists; I want her to have something to resist. She bites my lip just hard enough to pique my anger; I was waiting for the cue, some indication that she's ready to go on. I break the kiss, move behind her. I free her from the chair, but do not unfasten the cuffs.

"That will cost you, Highness. You will learn manners appropriate to a lady of your station; though it will be difficult, I will take your teaching upon myself. I am nothing if not magnanimous."

I remove the remnants of her clothing, tossing them to the floor where she'll soon be kneeling. I seat myself in the chair, pulling her to her knees. She kneels before me, straining at my hold on her hair. She is frisky. "The first lesson you will learn, Highness, is that no one is above the consequences of their actions. You behave like a spoiled brat; you will be treated like one." I roughly pull her across my knees, and caress her sweet, plump ass. She squirms, but makes no attempt to leave my lap. I pull a leather glove from my pocket, and put it on my right hand. I administer her consequences: twenty of them.

At five, she is still as belligerent as a naked woman in a pirate's lap can be; her ass is pinkening nicely.

At ten, she is breathing heavily, beginning to squirm. At fifteen, she is squeaking with each slap, trying to get away from the stinging redness of her own skin.

At twenty, she is begging me, "Please! No more! Stop, please! I will be good! No more, I beg you! Mercy!"

I know those aren't her safewords. I do not stop. I take the opportunity offered me to be merciless.

I rub my hand lightly over her sensitive skin and watch the goosebumps come up. She's sensitized, but not really hurting yet.

"Highness! You are learning! But I think you could do much better about asking for what you want politely. You must not have learned your lesson yet." Five more whacks, and she's ready to do something about stopping the sensation.

"Please, sir, I beg you to stop spanking me! I will behave as a lady of my station ought!" I pull her up from my lap and ease her back on to her knees in front of me.

"Really, Highness? And what might that station be?" She hesitates; I can tell she's deciding where she'd like things to go next. Sassiness will get her more punishment; too nice will make me suspicious; she's deciding how to open the opportunity for me to move into pleasure.

"My station is here, sir, at your feet. Until my father ransoms me, I will remain here. When my father comes for me, you will be forced to look me in the eye, and face the consequences of your actions."

Perfect. She leaves herself room to fight, and leaves me room to move in. I kiss her on the forehead and rise. She begins to rise also; I stop her. "Oh no, Highness; you should savor your newfound rank. You will crawl to the bed." She flashes me a look; I'm pushing it, I know. Not too far, but I'm nudging a negotiated boundary concerning humiliation. We agreed to none, but this might be construed as humiliation. Not as she defined it for me, though: context is everything. I'm willing to take the risk. She decides to comply; I sigh my relief under my breath. She follows me to the bed on her hands and knees, waiting for my next order.

"Up on the bed, Highness – gracefully. I wish to admire my new treasure." She moves like a cat in heat, this one. Once on the bed, she kneels seductively, head up, eyes lowered. She's good at this game.

"Lie down, Highness, and spread those lovely limbs." I add ankle cuffs, and fasten all four to the chains on my bed. I have her right where she wants me; later, she'll have me right where I want her. She told me she wants to give as much as she receives; I intend to make an abundant donation to that cause. Pleasure is a truly a gift that keeps on giving.

It was difficult to take her home after that experience. After snuggling, a snack and enough decompression to make sure we were both okay until tomorrow when we had more capacity for talking, it was the right thing to do. Mae West was wrong; too much of a good thing isn't always a good thing.

Saturday, afternoon

She said she'd call me when she woke up; she did. The steamy kiss I got after driving her home last night was filled with the exultation of promise. She's willing to play with me again, and I'd enjoy that tremendously. I don't think we're suited to a relationship or anything, but we certainly make the finest of playmates.

Decompression went well; her worst thing was the crawling, but she only rated it at a five. Her best thing was actually the repartée; she really liked how I spoke. She gave that a nine! My worst thing was worrying that I wouldn't be able to whip up a comeback when she cornered me verbally, but it was only a two. It would have been much worse if I had actually frozen. My best thing was what she can do with her tongue; I gave it an 8.5. It was our first time, after all.

But not our last.

A week later

I do the week-later check in call, just to make sure that full decompression has been achieved. She's fine; no additional issues; I had none, either. We're just chatting each other up, and she says, "Y'know, I've never done an interrogation or military scene, but I'd like to try. How do you feel about World War II?"

I'm renting some war movies tonight. I think I'll look swell in a uniform.

Appendix Three: Music

A good scene deserves a good soundtrack. I prefer CD's, usually compilations or soundtracks. I don't enjoy stopping a scene to turn a tape over; I favor the repeat button on a CD player. Musical tastes vary wildly; these are some of my favorites to scene to. In a multi-disk player, I'll start with a medium, the second disk of three would be a hard, and then a soft. In a five-disk player, it would be soft, medium, hard medium or another hard depending on the theme of the scene, and then a soft. For a single-disk player, I'll go with an album I know well and can repeat, pacing myself to the music. Whatever you choose, know thy music! The middle of a scene is not the best place to learn a new album; jarring changes in theme and tempo can take the wind right out of your sails.

The following list of suggestions is offered for your listening pleasure:

Hard

Braveheart Soundtrack
BT: ESCM; Movement in Still Life
Cradle of Filth: Cruelty and the Beast
Deep Forest: anything
Die Form: Extremum, Histories (2 disk set; disk 2 is better)
DJ Rap: Learning Curve
Gladiator Soundtrack
Graeme Ravelle: Original Motion Picture Score to The Crow
 (excellent!)
Korn: Issues

Lords of Acid: Our Little Secret
Nine Inch Nails: Downward Spiral
Nine Inch Nails: Pretty Hate Machine
Richard Marx: Flesh and Bone
Rob Dougan: Furious Angles
Soundtrack: 6he Hunted
Soundtrack: Dragonheart
Soundtrack: Fight Club
Soundtrack: From Hell
Soundtrack: Lost Highway
Soundtrack: Run Lola Run
Soundtrack: The Crow
Soundtrack: City of Angels

Medium

Afro Celt Sound System: Volume 2: Release
Changeling: The Hidden World
David Parsons: Ngaio Gamelan
Dead Can Dance: Serpent's Egg, Within the Realm of a Dying
 Sun
Delerium: Karma
Depeche Mode: Songs of Faith and Devotion
Elevation, Vol. 3: compilation
Enigma: whichever you're not sick of
Fluke: Risotto
Gordon, David & Steve: Serenity I & II
Govinda: Erotic Rhythms From the Earth
Hooverphonic: The Magnificent Tree
Jane Siberry: When I was a Boy
Lamb: Lamb
Massive Attack: Mezzanine
Mickey Hart: Planet Drum
Moby: Play
Portishead: Portishead
Sophie B. Hawkins: Tongues and Tails
Switchblade Symphony: Serpentine Gallery, Sinister Nostalgia
The Crystal Method: Vegas
The Cure: Bloodflowers
This Mortal Coil: It'll End in Tears

Soft

Phillips puts out an excellent collection of theme-oriented classical music: Mozart at Midnight, Baroque at Bathtime, Chopin and Champagne, and many others.

Enya

Celtic chants

Gregorian chants

Doula: In the Garden (Eastern flavor, great for belly dancing)

Mystic Bowls: Temple Sounds

Ravi Shankar

Loreena McKinnett

Sarah MacLachlan: Fumbling Towards Ecstasy

Madonna: Erotica

Roxy Music: Avalon

Soundtrack: Dangerous Beauty

George Winston: Spring, Summer, Autumn, and Winter (seasonal theme albums)

George Winston: Linus and Lucy: The Music of Vince Guaraldi (great for age play)

Appendix Four: Resource Guide

Books concerning sexuality and power exchange:

The Guide to Getting It On
Paul Joannides
Goofy Foot Press, Hollywood, CA

SM 101: A Realistic Introduction
Jay Wiseman
Greenery Press, Oakland, CA

The Ethical Slut: A Guide to Infinite Sexual Possibilities
Dossie Easton & Catherine A. Liszt
Greenery Press, Oakland, CA

Coming to Power: Writings and Graphics on Lesbian SM
SAMOIS
Alyson Publications, Boston

On the Safe Edge: A Manual for SM play
Trevor Jaques
WholeSM Publishing, Toronto

Different Loving
Gloria G. Brame, William D. Brame, Jon Jacobs
Prometheus Books, Villard, NY

Screw the Roses, Send Me the Thorns
Philip Miller & Molly Devon
Mystic Rose Books, Fairfield, CT

The New Bottoming Book, The New Topping Book
Dossie Easton & Janet W. Hardy
Greenery Press, Oakland, CA

The Encyclopedia of Unusual Sex Practices
Brenda Love
Greenwich Editions, London

Sex Disasters... and How to Survive Them
Charles Moser, Ph.D., M.D., & Janet W. Hardy
Greenery Press, Oakland, CA

The Ultimate Guide to Anal Sex for Women
Tristan Taormino
Cleis Press, San Francisco, CA

Kinky Crafts : 99 Do-It-Yourself S/M Toys
Ed. Lady Green and Jaymes Easton
Greenery Press, Oakland, CA

Safe, Sane, Consensual... And Fun
John Warren
Greenery Press, Oakland, CA

These books aren't sexually oriented, but they could do wonders for your creative life:

The Artist's Way: A Spiritual Path to Higher Creativity
Julia Cameron
C.G Putnam's Sons

Bird by Bird: Some Instructions on Writing and Life
Anne Lamott
Anchor Press

Writing Down the Bones: Freeing the Writer Within
Natalie Goldberg, Judith Guest
Shambhala Publications

If You Want to Write: A Book About Art, Independence and Spirit
Brenda Ueland
Graywolf Press

On Writing : A Memoir of the Craft
Stephen King
Pocket Books

To further add to your imagination bank:

Venus in Furs
Leopold Von Sacher-Masoch
Rhinoceros Books

The Marketplace, The Slave, The Trainer, The Academy, The Reunion
Laura Antoniou
Mystic Rose Books, Fairfield, CT

The Story of O
Pauline Reage, Jean Paulhan
Ballantine Books

Erotique Noire: Black Erotica
Ed. Reginald Martin
Anchor Books

On A Bed of Rice: An Asian American Erotic Feast,
Ed. Geraldine Kudaka
Anchor Books

Sex Toy Tales
Ed. Cathy Winks and Anne Semans
Down There Press (July 1998)

The Mammoth Book of New Erotica, The Mammoth Book of Erotica,
The Mammoth Book of International Erotica, The Mammoth Book of
Gay Erotica, The Mammoth Book of Historical Erotica
Ed. Maxim Jakubowski
Carroll & Graf

The Erotic Edge: Erotica for Couples
Ed. Lonnie Barbach, Ph.D.
Plume

Pillow Talk: Lesbian Stories Between the Covers
Ed. by Leslea Newman
Alyson Publications

Bondage on a Budget
Dante Davidson and Alison Tyler
Masquerade Books

The Claiming of Sleeping Beauty, Beauty's Punishment, Beauty's Release
A. N. Roquelaure
Plume

The Velvet Web
Christopher Summerisle
London Bridge Trade(October 1997)

Macho Sluts
Pat Califia
Alyson Publications Inc.

Videos

40 days, 40 nights (2002) Directed by: Michael Lehmann

9 1/2 Weeks. (1986) Directed by: Adrian Lyne

Basic Instinct (1992) Director-writer team of Paul Verhoeven and Joe Eszterhas

Better than Chocolate (1999) Directed by: Anne Wheeler

Body Heat (1981) Directed by: Lawrence Kasdan

Body of Evidence (1993) Directed by: Uli Edel

Bound (1996) Directed by: the Wachowski Bros., Cayetana Guillén Cuervo

Dangerous Liaisons (1988) Directed by: Stephen Frears

Delta of Venus. (1996) Directed by: Zalman King

Enchanted April (1992) Directed by: Mike Newell

Henry and June. (1990) Directed by: Phillip Kaufman

Jade (1995) Directed by: William Friedkin

Moonstruck (1987) Directed by: Norman Jewison

Purple Rain (1984) Directed by: Albert Magnoli

Quills (2000) Directed by: Philip Kaufman

Sliver (1993) Directed by: Phillip Noyce

Something Wild (1986) Directed by: Jonathan Demme

The Adventures of Don Juan (1949) Directed by: Vincent Sherman

The Adventures of Robin Hood (1938) Directed by: Michael Curtiz, William Keighley

The Black Swan (1942) Directed by: Henry King

The Hunger (1983) Directed by: Tony Scott

The Sea Hawk (1940) Directed by: Michael Curtiz

The Story of O. (1975) Directed by: Just Jaeckin

Racier videos:

Ageless Desire (2000)

Behind the Green Door, Mitchell Brothers (1972)

Bend Over Boyfriend (1998) Directed by: Shar Rednour and Jackie Strano.

Dead Men Don't Wear Rubbers (2001)

Edge Play (2001)

Euphoria (2002)

Every Woman Has a Fantasy 1 (1984) Directed by: Edwin Brown

Every Woman Has a Fantasy 3 (1995) Directed by: Edwin Durrell

Eyes of Desire 2 (1999)

Flashpoint (1998)

Human Equine videos: *www.thehumanequine.com/the1.html*

Immortal (2001) Directed by: Michael Raven

Kansas City Trucking Co. (1976)

Love's Passion (1998)

Matador (1997)

Outlaw Ladies (1981) Directed by: Henri Pachard

Please Don't Stop (2001)

Real Lesbians, Real Bondage (2002)

Sluts and Goddesses (1992) Directed by: Maria Beatty

The Chameleon (1989) Directed by: John Leslie

The Dinner Party (1994) Directed by: Cameron Grant

The Flesh Game (2002)

Tie Me Up! (2002) Cleo Dubois

Wonderland (2001) Directed by: Britt Morgan

Internet Resources

Star Westcott Designs (fabulous darkly romantic clothing, accessories and dolls)
www.starwestcottdesigns.homestead.com

Lion and Bear Glass (superb sex toys for the sensuous appetite; excellent quality)
www.lionandbear.com
(707) 822-5213

Good Relations (a lover's boutique; good service and prices)
www.goodrelations.com

Velvet Garden
www.velvetgarden.net

Dark Garden (great custom corsets)
www.darkgarden.net

Stormy Leather
www.stormyleather.com

Fetish Diva Midori (excellent information source)
www.fetishdiva.com

The Frugal Domme (quality adult toys at reasonable prices)
www.frugaldomme.com

Dr. Gloria G. Brame (an eclectic site for literate adults)
www.gloria-brame.com

Deviant
www.deviantclothing.co.uk

Diversified Services (great source; excellent links)
P.O. Box 35737
Boston, MA 02135
(617) 787-7426
www.diversifiedservices.biz

Pierre Silber Shoes (great service, larger-sized shoes for the woman in us all)
www.pierresilber.com

Medical Toys
www.medicaltoys.com

Happy Tails
www.flogger.com

Wicked! / Fetish Temple (amazing, high-quality work)
www.fetishtemple.com

Leather By Danny (amazing and versatile modular bondage system; gorgeous cuffs)
www.leatherbydanny.com

www.ravensgard.org/gerekr/costumef.html (a good general page with lots of links)

www.twincitiesmagic.com

www.makeupartist.com

www.cosmicoutfitters.com

www.centurynovelty.com

www.centerstagecostumes.com (best pirate hats and gear on the web!)

www.biologicdesigns.com

www.yosa.com

www.jeannienitro.com

www.water-hole.com/ponyboy.html (pony equipment and information)

www.affordablebondagegear.com/index1.html (some pony gear; other fun things)

www.thighhighboots.net

Organizations for Information and Support

There are many wonderful support organizations for the creative lifestyle. This list is not meant to be comprehensive, but should get you started. Select a source and contact them for further information.

Alabama

NAPEX Huntsville, AL
www.angelfire.com/al2/NAPEX/home.html

Alabama Group With No Name Huntsville
www.angelfire.com/al3/agwnn

The Red Chair Birmingham
P.O. Box 632, Birmingham, AL 35201-0632
rdchair.tripod.com

Cradle of Thorns Mobile
members.aol.com/ldydrklove/cradle2.htm

Arizona

Arizona Power Exchange Phoenix
PO Box 67532
Phoenix, AZ 85082-7532
(602) 415-1123
www.arizonapowerexchange.org

Desert Dominion Tucson
3843 E. 37th Street, in Tucson
(520) 792-6424.
www.desertdominion.org

Arkansas

WACA Springdale
www.waca-bdsm.com

California

The Society of Janus
P.O. Box 411523
San Francisco, CA 94141-1523
Hotline: (415) 292-3222
www.soj.org

Threshold
18034 Ventura Blvd PMB 426
Encino CA 91316-3516
(818) 782-1160
www.threshold.org

Wicked
P.O. Box 208, Tujunga, CA 91042-0208
hometown.aol.com/wickedonesxx

Orange Coast Leather Assembly
12832 Garden Grove Blvd., Garden Grove, CA 92843
OC at 714-534-0862
www.ocla.org

Modesto Discussion Group, Modesto
www.cv-bdsm.com

BDSMCommunity.Org Sacramento/Bay Area
www.bdsmcommunity.org
SAK Online Sacramento
www.sak.vg

NCBDSM Sacramento
ncbdsm.tripod.com

Club X San Diego
PO Box 3092
San Diego CA 92163-1092
(619) 685-5149
www.clubxsd.org

San Diego Lifestylers
www.sdldungeon.com

The 15 Association (men's SM group)
PMB 810
584 Castro Street
San Francisco, CA 94114-2594
(415) 673-0452
www.the15association.org

The Exiles (women's SM group)
P.O. Box 31266, San Francisco, CA 94131-0266
(415) 835-4739
www.theexiles.org

The Stampede! San Francisco Bay Area
www.the-stampede.com

Masquerade Woodland
PO Box 8049
Woodland, CA 95776-8049ade
www.themasque.org

Colorado

Denver PEP
(303) 575-1600
members.aol.com/bipolarber/extreme

Rocky Mountain Power Exchange
www.rmpe.org

Uncommon Ground
P.O. Box 103
Broomfield, Colorado 80038-0103
www.uncommon-ground.org

Connecticut

United LeatherFolk of Conneticut
lauragoodwin.org/folk.html

The Society Marion, CT
onesociety.tripod.com

Florida

Jacksonville Area Power Exchange Jacksonville, FL
www.angelfire.com/fl3/JAPEOrganization/page2.html

Orlando Power Exchange, Orlando, FL
www.orlandomunch.com/main.htm

Panama City Munch Group, Panama City, FL
www.bdsmlife.net/MistressScarlett/nick1.htm
DSGG Tampa & Vero Beach, FL
www.dssglive.com

Georgia

Kinky People of Georgia, Auburn
www.bobandmichelle.com/kpog

Atlanta PEP
1763 Montreal Circle, Tucker, Ga. 30084
www.mindspring.com/~pepatl

CAPE Augusta/Columbia, GA
www.angelfire.com/ga2/cape

Illinois

Dedicated and Safe, Chicago
P.O. Box 215
Blue Island, IL. 60406-0215
www.bdsm-chicago.com

Peoria D/S Forum
www.peoriadsforum.org

Links of Springfield
www.geocities.com/linksofspfld

Indiana

Keokuk BDSM Club
keokukclub.freeyellow.com

Indy Munch Indianapolis
P.O.Box 24265 Indianapolis, IN 46224-0265
home.indy.net/~shabu

Iowa

Iowa Stocks & Bonds
soli.inav.net/~moondanz

Quad Cities D/S Group Eastern Iowa/Western Illinois
www.geocities.com/SunsetStrip/Underground/6016

BDSM Dubuque
hometown.aol.com/bdsmdubuqu/FRED.html

Kansas

Kink in Northeast Kansas
come.to/K-I-N-K Kentucky

Kentucky

Louisville Munch Bunch Louisville, KY
www.geocities.com/WestHollywood/Village/4546

KUFS Lexington, KY
www.kufs.org

Louisiana

Louisiana Area Power Exchange Baton Rouge, LA
lpeabr.mybdsm.com

Acadiana Power Exchange Lafayette, LA
lpeabr.mybdsm.com

Different Delights Shreveport, LA
www.geocities.com/differentdelightsla/page1.htm

Shreveport Dungeon Shreveport, LA
www.shreveportdungeon.com/whatsnew.html

Michigan

Michigan Rope
www.michiganrope.com

MiChatOhs, Detroit
www.michatohs.org/Other_Groups.html

West Michigan Munch Group Grand Rapids
www.geocities.com/spnksinatra/WMM_Happy_Hour.html

KINK Kalamazoo
www.geocities.com/magnolians/1-KINK-Munch.htm

Minnesota

TIES Minneapolis
www.goldengate.net/~mdon/membership.htm

Missouri

CEPE Columbia
P.O. Box 94 Columbia, MO 65205
www.cepemo.com

St. Louis Leather and Lace
www.ier.com/users/stl3

Alternative Hedonistic Sources Kansas City, MO
P.O. Box 414545 - Kansas City, MO 64141
www.ahs-kc.org

Maine

CUFS Lewiston
www.cufsmaine.org/home.htm

Central Maine Alliance, Augusta
PO Box 3, Richmond, ME 04357
www.centralmainealliance.org

Maryland

At Ease, Baltimore
P.O. Box 23721
Baltimore, MD 21203-5721
www.baltimoreatease.org

Massachusetts

New England Leather Alliance, Brighton
P.O. Box 35728
Brighton, MA 02135-0013
(617) 876-6352
www.nla-newengland.org/nla2.html

Boston Dungeon Society
P.O. Box 1487
Westford, MA 01886
(617) 783-1386
www.bdsbbs.com/index.htm

Links, Northampton
members.tripod.com/~Links_69/links.html

Western Massachusetts Power Exchange
PO Box 90351
Springfield, MA 01139
(413) 782-8829
www.wmpe.org/Welcome.html

Mississippi

STAR Missisippi Gulf Coast
members.aol.com/hlflatina/Star.html

Nebraska

L2EP Omaha
www.geocities.com/l2ep2001

Nevada

Shibari Las Vegas
6170 W. Lake Mead Blvd., #374
Las Vegas NV 89108
(702) 225-9454
www.shibari.org

New Hampshire

PENE Keene
www.fortunecity.com/boozers/princessdi/725/index.htm

New Mexico

AEL Albuquerque
www.aelifestyles.mybdsm.com

New York

Rochester Kink Society Rochester, NY
www.rks-society.com/rksindex.htm

DomSubFriends New York City
www.domsubfriends.com/1home.shtml

The Eulenspeigel Society
P.O. Box 2783
New York, NY 10163
Tel: (212) 388-7022
www.tes.org

DsDesires, New York City
www.dsdesires.com/event.htm

Conversio Virium Columbia University, NYC
www.columbia.edu/cu/cv

SILK Bard College, NYC
student.bard.edu/clubs/silk/newsilk.html

North Carolina

CAPEX, Charlotte
www.geocities.com/capexwebpage/cp1.html

Dark Shadow, Raleigh
www.darkwhisper.com/darkshadow

LASH Shelby
www.wncnet.com/lash

SPANK Southern Piedmont/Sandhills
spank.mybdsm.com

Ohio

S.M.A.R.T., Cleveland
P. O. Box 770851, Lakewood, OH 44107
(440) 489-BDSM
www.ohiosmart.org

PEER Group, Cincinnati
P. O. Box 12872
Cincinnati, OH 45212-0072
(513) 763-3883
www.bdsm-peergroup.com

CORDS Columbus, OH
www.cordsinfo.org

MORAL Columbus, OH
www.moraldsl.org

Oklahoma

Oklahoma's People Exchanging Power, Oklahoma City
www.opep.com

Tulsa Dungeon Society Tulsa, OK
www.mybdsm.com/pages/TulsaDungeon

Oregon

Portland Leather Alliance
P.O. Box 5161
Portland, OR 97208
www.pdxleatheralliance.org

Pennsylvania

Burghermunch, Pittsburgh
www.burghermunch.org

The Mission, Philadelphia
members.tripod.com/~The_Mission

The Alpha Group, Westmoreland
www.geocities.com/The_AlphaGroup

South Carolina

This Thing That We Do, Columbia
www.t3wd.org/index3.html

SC LOCK, Greenville
www.sc-lock.com

Tennessee

Memphis Power Exchange
www.clpw.net/MPE/main.html

Memphis Links
1211 Ridgeway Road, PMB 155 Memphis, TN 38119
www.geocities.com/memphislinks/main-links.html

Smoky Mountain Power Exchange, Eastern Tennesee
links.magenta.com/~smpex

Tri-Cities BDSM
bdsm-tri-cities.web1000.com/Aboutthelist.htm

Texas

The Group With No Name, Austin
P.O. Box 81385
Austin, TX 78708-1385

K inc., Beaumont
members.aol.com/beaumontbdsm

Different Strokes, Dallas
www.differentstrokes.org

Houston PEP
www.hpep.org

Erotic Rose Society, Houston
www.houston-eros.com

Southern Jade, Rio Grande Valley
www.xanadu2.net/southern74

A Touch of Leather, Kileen
www.geocities.com/touch_of_leather

SASM San Antonio
www.sasmtx.com/home.html

Whips and Chains of Texas, Waco
PO Box 23173
Waco, TX 76702
www.geocities.com/wacotxsite/default1.htm

Utah

Utah Power Exchange, Salt Lake City
www.xmission.com/~spyder/upex

Virginia

WHIP West Virginia
whip.moonwolf.net

Virginia Power Exchange, various towns in Virginia
www.vapowerexc.mybdsm.com

Tidewater Individuals Exploring Domination
www.tiedva.org

Strictly Social Northern Virginia
www.geocities.com/novadssoc

Washington

The Triskeli Guild, Bellingham
PO Box 111
Bellingham, WA 98227-0111
www.triskeli.org

Spokane Power Exchange
www.geocities.com/SouthBeach/Pointe/1359

Washington, DC

Black Rose
www.br.org/index2.html

Wisconsin

Satyricon, Madison
satyricon-ds.hypermart.net

South East Wisconsin Discussion Group, Milwaukee
mobark.freeyellow.com/sitemap2.htm

Canada

This Group, Ottawa, Ontario
www.thisgroup.ottawabdsm.com

The EhBC Group, Waterloo, Ontario
www.ehbc.ca/home.html

Silver Birch Canadian Kinky Links
silverbirchbdsm.com/organizations.html

Edmonton O Society, Edmonton, Alberta
www.edmontonosociety.org

Body Perv Social Club, Vancouver, BC
www.bodyperve.com

Mythos Group
www.mythosgroup.org

Europe

Austria

Verein Libertine
Postfach 63
A-1011
Wien, Austria
0663 - 922 03 33

Belgium

VVSM Village (National organization for Belgium)
Azaleastraat 58
B-9920 Lovendegem
Belgium
tel +32 (93) 729 735
email: *info.eng@smvillage.com*
Web site: *www.vvsm-village.be*

Germany

LeChalet
Black Cabniet Room
Tel: (06485)4159
Arbeitsgemeinschaft S/M & Offentlichkeit
Postfach 11 44
D-24501 Neumünster
Hamburg, Germany
Tel: (06192)36516

SMania Nürnberg
Nürnberg, Germany
Tel: (0172)8633156
SMart Rhein-Ruhr e.V.
Postfach 19 05 32
42705 Solingen
Germany
Tel: + 49 (0) 201 874960

Holland

VSSM (meets in several different cities)
PO Box 3570
1001 AJ Amsterdam
Tel: (+31) 20 4202117
E-mail: *vssm@dds.nl*

Ireland

SM Zone
c/o Outhouse
6 South William Street
Dublin 2
Ireland
E-mail: *bonnie@bi.org*

Norway

SMIL Norway (English-speaking)
PO Box 3456
Bjolsen N-0406 Oslo Norway
Tel. +47 22 17 05 01 (Tuesday from 1800hrs to 2030hrs Central European Time)

Spain

El Chalet Cortijo, Mestanza
29130, De La Torre, Provincia
Malaga, Spain
Tel. 34-52-411063

Sweden

Club Sunrise (Speak Swedish only)
Box 686 S-53116
Lidkoping, Sweden

United Kingdom

The Fetish Contact Club - "Tied N Teased"
SASE to FCC
PO Box 609
Cardriff, CF1 7UK, England

Privilege Club
Gordon Sergeant
40 Old Compton Street
London W1V 5BP England

Red Stripe Club
PO Box 173
Rulslip, Middx HA4 GBH, England
tel. 01895 632290

The Tatou Club
BCM
London, WC1N 3XX, England

Lady O Society
BCM / 3406 London
WC1N 3XX, London (female submissives only)

Ukraine

Masoch Fund
PO Box 91, 290000
Lviv, Ukraine
tel/fax (0322)757144

Activism

No matter what you do with your sexuality, sexual freedom issues do pertain to you. The NCSF is our strongest political voice right now; discover and support them. You never know when you might need their services.

The National Coalition for Sexual Freedom
1312 18th Street NW, Suite 102
Washington, DC 20036
General Information: 202-955-1023
Fax: 202-955-1060
ncsfreedom@ncsfreedom.org

Appendix Five: Glossary

Note: The meanings of many of these terms are hotly debated both within the psychoanalytic communities and the alternative sexuality communities. Please accept this Glossary, not as an ultimate guide to the meanings of these words, but as an explanation of how they are used by this author.

24/7: A full-time D/S living arrangement

Acucullophallia: arousal by being cut

Age play: adopting a juvenile role, or the role of an adult who relates to said juvenile

Agrexophillia: arousal by knowledge of others hearing/aware of one's lovemaking

Algolagnia: arousal by pain

Altocalciphilia : arousal by high heels

Ass play: contact with the anus or rectum, from stimulation to insertion

Asphyxiaphilia: love of controlling the breathing

Autoerotic: masturbation

BDSM: acronym for bondage/discipline/dominance/submission/ sadism/masochism. Umbrella term for many alternative sexual practices

Boi: a female with a young male identity or a young gay man

Bondage: to restrain with rope or other device intended for the purpose of restraint

Bottom: the receiver of sensation play; has submissive connotations

Breast torture: sensation play focusing on the breasts

Caging: placing in a cage or pet kennel

CBT: cock and ball torture (see Resource Guide, Books)

Chastity device: device intended to prevent sexual satisfaction

Collar and leash: often symbolic of a BDSM arrangement

Coprophilia: arousal by playing with fecal matter; also called scat play

Creativity: the ability to actualize a concept held in the imagination

D/S: dominance and submission

Dacryphilia: arousal from tears

Depilation: shaving

Dildo: device designed for vaginal insertion

Domination: subjugating another to one's will

Domm(e): one who subjects others to domination

Electrotorture: use of electrical stimulation devices (TENS units, violet wands)

Exhibitionism: gratification through being observed

Fisting: anal, vaginal; insertion of a hand into said orifices

Flogger: many-tailed whip used to inflict sensation

Gangbang: multiple sexual givers with one receiver

Heavy play: play involving high levels of intense stimulation

Imagination: the formation of a mental image not real or present

Kink: statistically deviant sexual practices; also used to refer to one's own proclivities

Klismaphilia: arousal by enema

Lifestyle: BDSM term used to refer to those who practice alternative sex on a regular basis and for whom kink is essential to life gratification as well as sexual gratification

Maieusiophilia: arousal by expecting mothers

Masochism: gratification, sexual and non-, through receiving pain

Mindfuck: deliberate manipulation of perceptions; usually associated with control (D/S)

Negotiations: discussion of boundaries and desires to facilitate personal encounters

Newbie: someone new to the kink community

Onanism: sexual love of self, self-pleasure

Pervert: self-identification for some persons into kink

Phobophilia: arousal by terror

Play: to engage in consensual, alternative energy exchange

Play party: a party where play occurs, often facilitated by available equipment and/or toys

Podophilia: arousal by feet

Power exchange: refers to the dynamic of surrendering one's energies to someone who reshapes them, returning them in the form of heightened experience

ProDom(me): Professional dominant

Retifism: arousal by shoes or boots

Rimming: licking the anal sphincter

Roleplaying: adopting roles in play for sensual, sexual gratification

Sadism: gratification from the administration of pain

Scene: a special time and place set aside for the exchange of energies intended for mutual gratification

Sensation play: use of tactility in play for sensation, sometimes including pain

Slave contract: a negotiated agreement delineating terms of service

Sub: submissive; one who is gratified by serving

Top: usually a sadistic dominant

Toys: implements intended or adapted to the administration of sensation

Transvestitism: gratification in wearing a different gender's clothing

Urolagnia: arousal by urine

Vanilla: absence of kink or alternative practices

Voyeurism: gratification through observation

Appendix Six: Negotiation Forms and Formats

Fantasy Made Flesh is an introductory book about erotic roleplay, and was not written nor intended to be a complete primer to all forms of erotic power exchange. If you want to play with any kind of experience involving bondage, mental control, challenging emotions, or strong physical sensation, it is essential that you obtain and read a good basic book on BDSM – such as SM 101: A Realistic Introduction, *by Jay Wiseman, which includes the negotiation form reprinted here with permisison.*

A good, basic negotiation should cover 16 points:

1. The people involved. Who will take part? How much experience do they have with the activities proposed? Who, if anybody, will watch?

2. Roles. Who will be dominant? Who will be submissive? Any chance of switching roles? Will the participants be acting out a particular fantasy such as teacher/schoolchild, pirate/captive or owner/dog?

Is there clear agreement by the submissive to obey, within limits, the dominant's orders? Can the dominant "overpower" the submissive? "Force" them to do something? What about verbal resistance? Physical resistance? May the submissive try to "turn the tables" on the dominant? Will the submissive agree to wear a collar? Will they agree to address the dominant as "Master," "Mistress," or some similar term?

Warning: Physical resistance can easily be misinterpreted. I therefore strongly recommend that, particularly for the first few sessions, the dominant allow any physical resistance by the submissive to "succeed" immediately. A dominant should tell the submissive, in so many words, that they will consider any physical resistance on the submissive's part,

no matter how slight, a "strong yellow" and will not even begin to try to overcome it. Major physical resistance will be considered a "red" and will result in the session instantly ending.

3. Place. Where will the session occur? Who will ensure privacy? (Usually the dominant.)

4. Time. When will the session begin? How long will it last? How will its beginning and end be signaled? Who will keep track of time (again, usually the dominant).

Note: Unless deliberately built into the play, a clock visible to the submissive often detracts from the scene's energy.

5. Oops! SM play is always somewhat unpredictable. No matter how carefully you negotiate and plan, accidents, misperceptions, miscommunications and sometimes unintentional injuries will occasionally happen. Therefore, it's a good idea to talk about these matters ahead of time, discussing how you will handle them and how you will treat each other if they do occur. It's important to agree that both parties are negotiating and playing in good faith, and that any mishaps will be discussed in a constructive, non-blaming way.

6. Limits. This mainly involves the submissive's physical and emotional limits. Do they have any relevant health problems such as a heart condition, high blood pressure, or epilepsy? Are they wearing glasses or, especially, contact lenses? How well do they see without them? Do they have any physical limitations? I would hesitate, for example, to tie someone with their arms stretched tightly overhead if they have a history of a dislocated shoulder. Any history of plastic surgery (you don't want to deliver strong whip strokes to breasts that contain implants)?

Any history of back surgery, joint surgery, sprained ankles, neck injury, joint disorders, arthritis, etc.? Any other range-of-motion limits?

The submissive *must* be completely honest with their dominant about limits. Some submissives conceal information because they may feel embarrassed or fear that revealing it may cause the dominant to decide not to play with them. This is stupid. While revealing the information may indeed cause a dominant to cancel a session, withholding it may cause a disaster.

Emotional limits: Any known phobias or other emotional hotspots? Any "real life" incidents in their past that might come up? Note: Both players should understand that SM play has a small but distinct chance of touching an unknown emotional hot spot in either player.

7. Sex. It's crucial to agree clearly and specifically, *before* beginning the session, about exactly what kind of conventional sexual contact, if any, is mutually acceptable. What about masturbation? Cunnilingus? Fellatio? Swallowing semen? Analingus? Vaginal intercourse? Anal in-

tercourse? Condoms? Birth control precautions? Does either person have herpes? Has either tested positive for the AIDS virus? Keep in mind that not everybody agrees on the definition of "safer sex practices"; before you begin your session, make sure you are in agreement regarding which activities will involve a barrier and which will not.

Don't act shy or squeamish on this point. The negotiations on conventional sex absolutely *must* be clear and agreed upon before going further. Failure to make sure of this point, or going into the session "hoping for the best," can set the stage for a very frustrating session – as I have learned from experience.

8. Intoxicants. Don't play if either of you is seriously drunk or stoned. Particularly avoid drugs that make the submissive insensitive to pain or that impair the dominant's judgment or coordination (SM often has a potent, drug-like effect on many people. It needs little outside help).

As of this writing, I know of no serious accidents during SM play where the players used only small amounts of beer, wine, or marijuana. I suggest avoiding SM play if either person is under the strong influence of liquor, heroin, cocaine, amphetamines, tranquilizers, barbiturates, or potent psychedelics. Many injuries and nonconsensual incidents can be traced directly to players using strong intoxicants, especially alcohol!

Note: Introducing any intoxicant not previously agreed upon is serious misbehavior. If the dominant pulls out hard liquor, cocaine, or something similar, the submissive should immediately call "red," get dressed, and leave.

9. Bondage. Who will be tied up? To what extent? (Some submissives allow a new dominant to bind them, but don't allow the dominant to tie them *to* something such as a bed or chair.) What about blindfolds? Gags? Hoods? (Wise players avoid blindfolds, gags, and hoods during the first few sessions.) Does the submissive have a history of claustrophobia? Have they been bound, gagged, blindfolded, or hooded before? How did they react?

10. Pain. How does the submissive feel about receiving pain? Can they be spanked? Paddled? Whipped? Slapped? What about nipple clamps? Genital clamps? Clamps elsewhere? How about hot creams? Ice? Anything else painful? Some submissives cheerfully admit they are "pain sluts." Others hate receiving pain, but will endure it if doing so pleases their dominant.

11. Marks. Will it cause the submissive problems if the session leaves marks? (Whipping is likely to mark.) Do they know from experience how easily they mark? Do they understand it might be difficult to tell whether a given activity is marking them? Do they care if an activity draws small amounts of blood? If it's crucial that the submissive not be

marked, then it's probably best to avoid spanking, whipping, clamping, pinching, and so forth.

(Note: Sometimes marks not normally visible can be "brought to the surface" by a hot shower. This can happen up to several days after the session.)

12. Humiliation. This can include "verbal abuse," forced exhibitionism, water sports (peeing on the submissive), enemas, slapping the face, spitting, and scat (feces) games. Does the submissive have any experience in these areas? What was their reaction? Are they curious? Are these areas definite turn-offs?

Playing with humiliation is playing with emotional dynamite. This area, therefore, is exceptionally important to negotiate. Never "surprise" a submissive with a golden shower or something similar. Their reaction could be immediate and extreme – panic, intense shame, violent rage.

Remember, the less well you know someone, and the less experience you have with them, the more carefully you must proceed. This is especially true about humiliation.

13. Safewords. I recommend using at least two safewords: one for "lighten up," and one for "stop completely." These are usually enough for a basic session. I also strongly recommend including the "two squeezes" technique.

If the players will use a gag or hood, they *must* agree upon non-verbal "safe signals." Again, gagging a submissive without previously setting up a non-verbal safeword and getting their consent is asking for trouble.

14. Opportunities. Is there anything either person has wanted to try but not had a reasonable opportunity to experience? Is there anything they feel curious about? Does either have unique talents or skills to offer?

15. Follow-up. What arrangements can be made for the two people to spend "straight time" together immediately after the session? What about follow up contact the next day? A week later? If a crisis occurs?

16. Anything Else? Is there anything else to discuss or negotiate about before beginning?

Sixteen points seem like a lot, yet with practice experienced players can cover them in only five to ten minutes – if they closely agree. On the other hand, negotiations may take *much* longer. As a rule of thumb, if it takes over an hour to agree on all points, you may not be compatible enough to play together then. Stop for the time being and schedule another meeting.

Caution: Negotiate only when both of you are alert and in good spirits. If one or both of you feels tired, sleepy, sad, angry, fearful, or otherwise upset, negotiate (and play) later.

I have used this 16-point checklist with many new partners, and for more than eight years. In all of that time, I have never had a bad session after reaching clear agreement on all 16 points prior to play.

To Help You Remember

The sixteen points are: people, roles, place, time, oops, limits, sex, intoxicants, bondage, pain, marks, humiliation, safewords, opportunities, follow-up, and "anything else?" The first letters of these words, respectively, are: P, R, P, T, O, L, S, I, B, P, M, H, S, O, F, A. I've devised a saying to help you remember. The first letter of each word matches the first letter of a negotiation point.

"Placing Ropes Properly Tight Only Lets Sex Intensify. Binding Penises May Hurt, So Only Fuck Animals."

Its delightful nonsense-ness helps you remember it. (Please don't fuck any animals. I only put that word in because its vividness will help you remember the saying. I oppose bestiality.)

Say the acronym aloud a few times. Write it down. Post it somewhere. With only a little repetition, it's easy to remember and use.

It helps to prepare a negotiation form and fill in the blanks as you negotiate. This helps both players stay clear about what they agreed upon (and what they didn't).

Finally, remember that neither player, *must* do anything they previously agreed they would do. While they should make a good-faith effort to obey, they may call their safeword if the session becomes too intense. Dominants, too, have the right to use safewords.

Negotiation Forms

To help clarify matters as you negotiate, and to help you remember what your agreements were once the play begins, I've included two "negotiation forms" in this section. As with your income tax, you can use either the "short form" or the "long form" as appropriate. Among other things, looking over these forms, particularly the long form, helps people realize how many different aspects of SM play can come up during a session. That in itself can be highly educational and clarifying.

Notice: Permission is hereby given to photocopy (only) the negotiation forms in this book.

Negotiation Short Form

Note: Please use the back of the form if additional space is needed.

1. People_____

2. Roles_____

3. Place_____

4. Time_____

5. Oops_____

6. Limits_____

7. Sex_____

8. Intoxicants_____

9. Bondage_____

10. Pain_____

11. Marks_____

12. Humiliation_____

13. Safewords_____

14. Opportunities_____

15. Follow-up_____

16. Anything Else?_____

Negotiation Long Form

Note: Please use the back of the form if additional space is needed.

People

Who will take part?_____

Who will watch? _____

Note: The session will involve only those people specifically named above. Will any permanent record be made of the session (photographs, audiotapes or videotapes)? ☐ Yes ☐ No

Explanation_____

Roles

Who will be dominant? _____

Who will be submissive? _____

Type of scene:
 ☐ master/slave
 ☐ mistress/slave
 ☐ captive
 ☐ servant/butler/etc.
 ☐ cross-dressing/gender play
 ☐ age play
 ☐ animal play
 ☐ other

Any chance of switching roles? ☐ Yes ☐ No

Explanation: _____

Will the submissive promptly obey? ☐ Yes ☐ No

Explanation: _____

May the dominant "overpower" or "force" the submissive? ☐ Yes ☐ No

Explanation: _____

May the submissive verbally resist? ☐ Yes ☐ No

Explanation:_____

May the submissive physically resist? ☐ Yes ☐ No

Explanation: _____

Does resistance equal a "strong yellow"? ☐ Yes ☐ No

Explanation: _____

May the submissive try to "turn the tables"? ☐ Yes ☐ No

Explanation: _____

Does the submissive agree to wear a collar? ☐ Yes ☐ No

Explanation: _____

The submissive agrees to address the dominant by the following title(s):_____

Place

Location: _____

Who will ensure privacy?_____

Time

Begin at: _____

Length: _____

Beginning signal:_____

Ending signal: _____

Who will keep track of time?_____

Oops

Does everybody involved understand that there is some risk of accident, miscommunication, misperception and/or unintentional injury? □ Yes □ No

Does everybody involved agree to discuss any mishaps in a constructive and non-blaming manner? □ Yes □ No

Limits

Submissive's limits

Submissive's physical/emotional/SM activity limits:_____

Any problems with the submissive's...

heart □ Yes □ No

lungs □ Yes □ No

neck/back/bones/joints □ Yes □ No

kidneys □ Yes □ No

liver □ Yes □ No

nervous system/mental □ Yes □ No

Explanation: _____

Is the submissive wearing contact lenses? □ Yes □ No

Does the submissive suffer from carpal tunnel syndrome or similar? □ Yes □ No

Does the submissive have a history of:

seizures: □ Yes □ No

dizzy spells: □ Yes □ No

diabetes: □ Yes □ No

high or low blood pressure: □ Yes □ No

fainting: □ Yes □ No

asthma: □ Yes □ No

hyperventilation attacks: □ Yes □ No

Describe any phobias: _____

Submissive's other medical conditions:
Any surgical implants (breast, face, etc.)? ☐ Yes ☐ No
Explanation: _____
Is the submissive taking aspirin? ☐ Yes ☐ No
Is the submissive taking ibuprofen, Aleve, or other non-steroidal, anti-inflammatory drugs? ☐ Yes ☐ No
Is the submissive taking antihistamines? ☐ Yes ☐ No
Other medications submissive is taking: _____
Allergic to:
 bandage tape: ☐ Yes ☐ No
 nonoxynol-9: ☐ Yes ☐ No
Other allergies _____

In case of emergency notify: _____

Dominant's Limits
Dominant's physical/emotional/SM activity limits_____

Any problems with the dominant's...
heart ☐ Yes ☐ No
lungs ☐ Yes ☐ No
neck/back/bones/joints ☐ Yes ☐ No
kidneys ☐ Yes ☐ No
liver ☐ Yes ☐ No
nervous system/mental ☐ Yes ☐ No
Explanation: _____
Dominant's other medical conditions: _____
Medications dominant is taking: _____
In case of emergency notify:_____
Is the dominant certified in First Aid/CPR? ☐ Yes ☐ No
Safety gear on hand:
paramedic scissors: ☐ Yes ☐ No
flashlight: ☐ Yes ☐ No
first aid kit: ☐ Yes ☐ No
blackout light: ☐ Yes ☐ No
fire extinguisher: ☐ Yes ☐ No
Will the play be in an isolated area such as a farmhouse? ☐ Yes ☐ No
If yes, what will ensure the submissive's safety if the dominant becomes unconscious?
 no bondage to chair, bed, etc.: ☐ Yes ☐ No
 no gag: ☐ Yes ☐ No

silent alarm: ☐ Yes ☐ No
third person present: ☐ Yes ☐ No
telephone/radio/panic button within submissive's reach:
☐ Yes ☐ No
Other: _____

Sex

Does any participant believe they might have a sexually transmitted disease? ☐ Yes ☐ No
Explanation: _____
Does any participant believe they might have herpes? ☐ Yes ☐ No
Explanation: _____
Have participants been tested for HIV? ☐ Yes ☐ No
Has any participant tested positive? ☐ Yes ☐ No
Explanation: _____
Check which of the following sexual acts are acceptable:
Masturbation
☐ dominant to submissive ☐ submissive to dominant
☐ self-masturbation by submissive
☐ self-masturbation by dominant
Fellatio
☐ dominant to submissive ☐ submissive to dominant
Cunnilingus
☐ dominant to submissive ☐ submissive to dominant
Analingus
☐ dominant to submissive ☐ submissive to dominant
Anal fisting
☐ dominant to submissive ☐ submissive to dominant
Vaginal fisting
☐ dominant to submissive ☐ submissive to dominant
Vaginal intercourse
☐ dominant to submissive ☐ submissive to dominant
Anal intercourse
☐ dominant to submissive ☐ submissive to dominant
Is swallowing semen acceptable? ☐ Yes ☐ No
Is any participant menstruating? ☐ Yes ☐ No
Will sex toys such as vibrators, dildoes, butt plugs, etc. be used? ☐
Yes ☐ No
Describe: _____

Which of the above activities will involve birth control pills, diaphragms, spermicidal suppositories, lubricants containing nonoxynol-9, or contraceptive foam/suppositories/gel?_____

Which of the above activities will involve condoms, gloves, dental dams, and/or other barriers?_____

Intoxicants

The dominant can use (only) the following intoxicants during the session:_____

Acceptable quantity: _____

The submissive can use (only) the following intoxicants during the session:_____

Acceptable quantity: _____

Bondage

The submissive agrees to allow (only) the following types of bondage:

hands in front: ☐ Yes ☐ No

hands behind back: ☐ Yes ☐ No

ankles: ☐ Yes ☐ No

knees: ☐ Yes ☐ No

elbows: ☐ Yes ☐ No

wrists to ankles (hog-tie): ☐ Yes ☐ No

spreader bars: ☐ Yes ☐ No

tied to chair: ☐ Yes ☐ No

tied to bed: ☐ Yes ☐ No

use of blindfold: ☐ Yes ☐ No

use of gag: ☐ Yes ☐ No

use of hood: ☐ Yes ☐ No

use of rope: ☐ Yes ☐ No

use of tape: ☐ Yes ☐ No

use of handcuffs/metal restraints: ☐ Yes ☐ No

use of leather cuffs: ☐ Yes ☐ No

suspension: ☐ Yes ☐ No

mummification with plastic wrap, body bag, or similar techniques: ☐ Yes ☐ No

Any past bad experiences by either person with bondage, gags, blindfolds, and/or hoods?: ☐ Yes ☐ No

Explanation: _____

Pain

Submissive's general attitude about receiving pain:

☐ likes ☐ accepts ☐ neutral ☐ dislikes ☐ will not accept

Quantity of pain submissive wants to receive: ☐ none ☐ small ☐ average ☐ large

Explanation: _____

Dominant's general attitude about giving pain:

☐ likes ☐ gives ☐ neutral ☐ dislikes ☐ will not give

Quantity of pain dominant wants to give: ☐ none ☐ small ☐ average ☐ large

Explanation: _____

Will the "now" technique be used? ☐ Yes ☐ No

Explanation: _____

Will the "nod" technique be used? ☐ Yes ☐ No

Explanation: _____

Will the "one to ten" technique be used? Will the "now" technique be used? ☐ Yes ☐ No

Explanation: _____

The following types of pain are acceptable:

spanking: ☐ Yes ☐ No

paddling: ☐ Yes ☐ No

whipping: ☐ Yes ☐ No

caning: ☐ Yes ☐ No

face slaps: ☐ Yes ☐ No

biting: ☐ Yes ☐ No

nipple clamps: ☐ Yes ☐ No

genital clamps: ☐ Yes ☐ No

clamps elsewhere: ☐ Yes ☐ No

locations: _____

hot creams: ☐ Yes ☐ No

ice: ☐ Yes ☐ No

hot wax: ☐ Yes ☐ No

tickling: ☐ Yes ☐ No

Other types/methods of pain: _____

Additional remarks: _____

Marks

Is it acceptable to the submissive if the play leaves marks? ☐ Yes ☐ No

Visible while wearing street clothes? ☐ Yes ☐ No

Visible while wearing a bathing suit? ☐ Yes ☐ No

Other: _____

Is it acceptable to the submissive is the play draws small amounts of blood? ☐ Yes ☐ No
Explanation: _____
How easy or difficult has it been to mark the submissive in the past?

Erotic Humiliation

The submissive agrees to accept being referred to by the following terms:
The submissive agrees to the following forms of erotic humiliation:
"verbal abuse": ☐ Yes ☐ No
enemas: ☐ Yes ☐ No
forced exhibitionism: ☐ Yes ☐ No
spitting: ☐ Yes ☐ No
water sports: ☐ Yes ☐ No
scat games: ☐ Yes ☐ No
other: _____
Any prior really good or really bad experiences in these areas?

Safewords

Safeword #1 and its meaning: _____
Safeword #2 and its meaning:_____
Safeword #3 and its meaning:_____
Non-verbal safewords and their meaning: _____
Will "two squeezes" be used? ☐ Yes ☐ No
Will the "extended hand" technique be used? ☐ Yes ☐ No

Opportunities/Special Skills

Anything in particular either party would like to try or explore?

Follow-Up

(Please include a note about who will initiate contacts.)
After the session: _____
The next day: _____
A week later: _____
In case of a crisis: _____

Anything Else?

What will become of this form after the session? _____

Dominant

Overall feeling: one to ten scale (ten tops) _____

Best part: one to ten scale _____

Worst part: one to ten scale _____

Other comments: _____

Submissive

Overall feeling: one to ten scale (ten tops) _____

Best part: one to ten scale _____

Worst part: one to ten scale _____

Other comments: _____

About The Author

Deborah Addington has devoted herself to discovering how spirituality, kink and sexualty can help make sense of our crazy world. She is an author, student of literature, teacher, poet, journalist, 15-year veteran of the BDSM community, pornographist, sexualist, seeker of the divine and Truth. She is a body modification artist specializing in scarification and skin etching. She has a degree in Literature and a credential in Women's Studies with an emphasis on ending violence against women. She is an ordained Cleric in the tradition of Modern Mysticism.

Through sexuality training and education, she specializes in helping others to find and travel their own paths as well as assisting others to have the best, hottest sex possible. She teaches a spiritual course in BDSM: Erotomancy, as well as ritual scarification, play piercing, vaginal fisting and female genitorture. She is available to teach Erotic Roleplay workshops; she can be contacted through Greenery Press or directly at *Deborah@FistAndFangs.com*. For a complete class listing and schedule, please visit *www.FistAndFangs.com*.

On the outside, she is 38, six feet tall, dark-haired, tattooed and pierced. On the inside, she is hungry for knowledge, irreverent, and extremely frolicsome. She is deliciously sadistic, dominant in nature, and enjoys living on her own edge while encouraging others to find theirs. She lives in California's lovely and isolated far Pacific Northwest where she writes, commits art and tries to keep sane. *Fantasy Made Flesh* is her second book.

Other Books from Greenery Press

GENERAL SEXUALITY

Big Big Love: A Sourcebook on Sex for People of Size & Those Who Love Them
Hanne Blank $15.95

The Bride Wore Black Leather... And He Looked Fabulous!: An Etiquette Guide for the Rest of Us
Andrew Campbell $11.95

The Ethical Slut: A Guide to Infinite Sexual Possibilities
D. Easton & C.A. Liszt $16.95

A Hand in the Bush: The Fine Art of Vaginal Fisting
Deborah Addington $13.95

Health Care Without Shame: A Handbook for the Sexually Diverse & Their Caregivers
Charles Moser, Ph.D., M.D. $11.95

The Lazy Crossdresser
Charles Anders $13.95

Look Into My Eyes: How to Use Hypnosis to Bring Out the Best in Your Sex Life
Peter Masters $16.95

Swing Stories: First-Person Tales of Sexual Adventure
Jan & Bridget Abrams $16.95

Turning Pro: A Guide to Sex Work for the Ambitious and the Intrigued
Magdalene Meretrix $16.95

When Someone You Love Is Kinky
D. Easton & C.A. Liszt $15.95

BDSM/KINK

The Bullwhip Book
Andrew Conway $11.95

A Charm School for Sissy Maids
Mistress Lorelei $11.95

The Compleat Spanker
Lady Green $12.95

Family Jewels: A Guide to Male Genital Play and Torment
Hardy Haberman $12.95

Flogging
Joseph W. Bean $11.95

Jay Wiseman's Erotic Bondage Handbook
Jay Wiseman $16.95

The Loving Dominant
John Warren $16.95

Miss Abernathy's Concise Slave Training Manual
Christina Abernathy $11.95

The Mistress Manual: The Good Girl's Guide to Female Dominance
Mistress Lorelei $16.95

The New Bottoming Book
D. Easton & J.W. Hardy $14.95

The Sexually Dominant Woman: A Workbook for Nervous Beginners
Lady Green $11.95

The Topping Book: Or, Getting Good At Being Bad
D. Easton & C. A. Liszt $11.95

FICTION FROM GRASS STAIN PRESS

The 43rd Mistress: A Sensual Odyssey
Grant Antrews $11.95

Haughty Spirit
Sharon Green $11.95

Justice and Other Short Erotic Tales
Tammy Jo Eckhart $11.95

Love, Sal: letters from a boy in The City
Sal Iacopelli, ill. Phil Foglio $13.95

Murder At Roissy
John Warren $11.95

The Warrior Within (part 1 of the Terrilian series)
Sharon Green $11.95

The Warrior Enchained (part 2 of the Terrilian series)
Sharon Green $11.95

Please include $3 for first book and $1 for each additional book with your order to cover shipping and handling costs, plus $10 for overseas orders. VISA/MC accepted. Order from:

 greenery press

1447 Park St., Emeryville, CA 94608
toll-free 888/944-4434 http://www.greenerypress.com